AN INSPIRATION TO ALL WHO ENTER

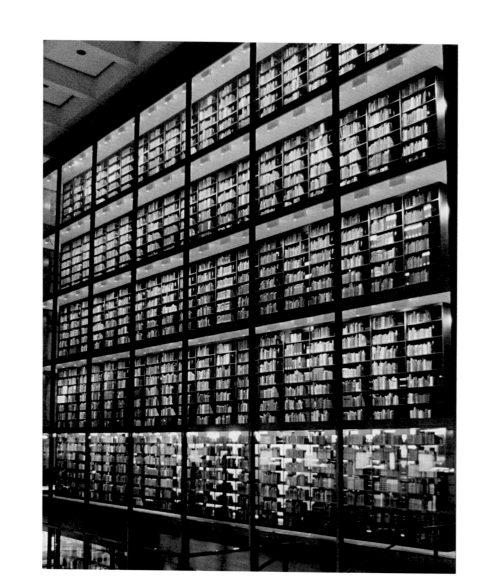

AN INSPIRATION TO ALL WHO ENTER

**Fifty Works from Yale University's
Beinecke Rare Book & Manuscript Library**

Edited by Kathryn James

With contributions by Raymond Clemens, Kathryn James, Nancy Kuhl, George Miles, Kevin Repp, Edwin C. Schroeder, and Timothy Young

Published by Beinecke Rare Book & Manuscript Library

Distributed by Yale University Press, New Haven and London

Published by Beinecke Rare Book & Manuscript Library, P.O. Box 208240, New Haven, Connecticut 06520-8240 beinecke.library.yale.edu

Distributed by Yale University Press, P.O. Box 209040, New Haven, Connecticut 06520-9040 www.yalebooks.com/art

ISBN 978-0-300-19642-9
Library of Congress Control Number: 2013943189
A catalog record for this book is available from the British Library.
First printing

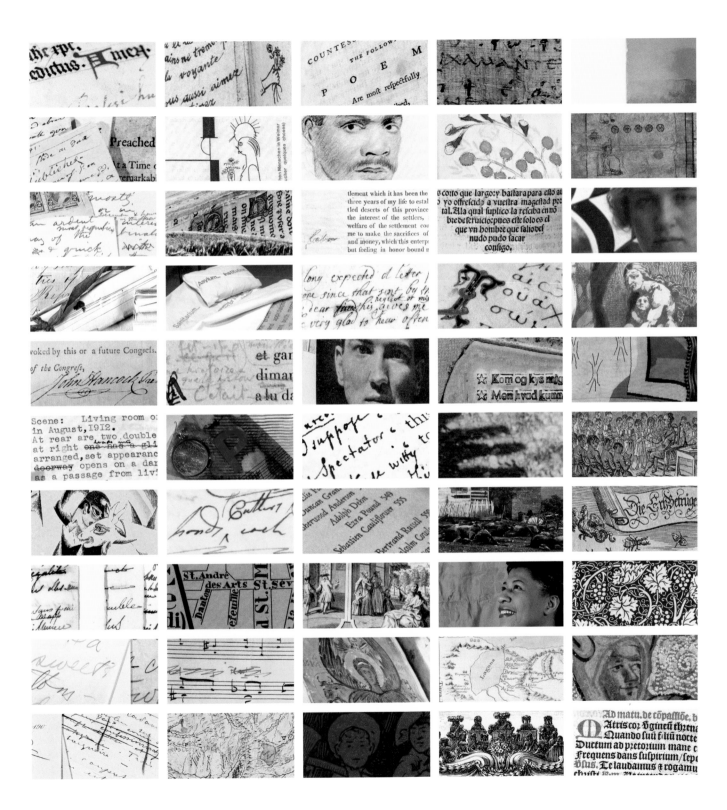

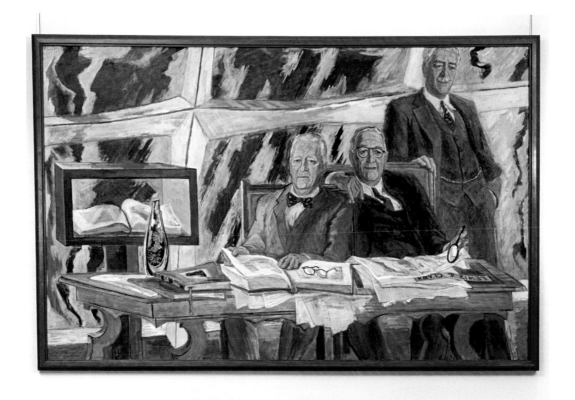

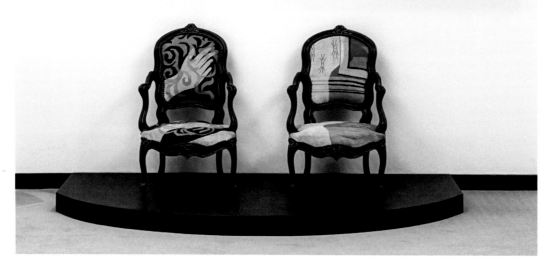

Facing the Beinecke Library reading room: A portrait by Franklin Chenault Watkins of Edwin J., Frederick W., and Walter Beinecke (1965), above two children's chairs, designed by Pablo Picasso and embroidered by Alice B. Toklas (1930).

Director's Preface

Edwin C. Schroeder

In 2013, the Beinecke Rare Book & Manuscript Library marks the fiftieth anniversary of its opening on October 14, 1963. As part of a yearlong celebration, the Library has organized three exhibitions exploring the manuscript, printed, and visual collections in turn. Each curator selected noteworthy items for inclusion in a series of exhibitions demonstrating the breadth and depth of the Library's holdings. For this book, fifty items were chosen from the three exhibitions, highlighting both the Library's traditional strengths and the new directions that it has taken over the first five decades of its history.

Although the Beinecke Library is still young, its collections date to the founding of Yale University. The University's first library catalog was printed in 1743, and the surviving books listed there now reside at the Beinecke Library. The Beinecke's creation in 1963 drew together the collections of the Rare Book Room, the Yale Collection of German Literature, the Yale Collection of American Literature, the Western Americana Collection and, soon after the Library opened, the James Marshall and Marie-Louise Osborn Collection of English Literary and Historical Manuscripts. Over the past fifty years these collections have grown together, complementing each other in ways not necessarily anticipated when the Library opened. Today the Library continues to build its collections in each of these core areas of strength, while cultivating their related fields: Modernism and the avant-garde; music; photography; the archives of contemporary authors and poets; and the documentation of pivotal historical moments such as the eighteenth-century trans-Atlantic world and the post-war European counter-culture.

Today, as in 1963, collection development depends on partnerships among collectors, donors, curators, and the antiquarian booktrade. The generosity of donors and collectors is symbolized in the lobby of the Library by the portrait of the Beinecke brothers (fig. 1). Captured in the same tiger's-eye light that still infuses the marble walls each day, Edwin J., Frederick W., and Walter Beinecke are depicted as collectors and scholars, studying books and manuscripts in the Library they created to hold and preserve the Yale collections. The portrait, showing both the Gutenberg Bible and Lewis and Clark

survey journals, hangs over two small chairs designed by Pablo Picasso for Gertrude Stein and Alice Toklas, whose papers are central to the Yale Collection of American Literature, one of the Beinecke's first and core collections.

At the same time, the Beinecke Library's collections have forged new strengths in these initial decades, developing in ways that reflect the unexpected opportunities, trends in scholarship, and changes in the rare book and manuscript field over the last half century. This growth reflects the vitality of the Library, whose directors, curators, scholars, and friends have played a remarkable role in shaping not only the collections, but the teaching and scholarship that would influence students now and in the Library's future. Patricia Willis, former Curator of the Yale Collection of American Literature, once remarked that she was building collections to be used by the next generation of scholars.

Today the Library adds materials in new formats and new subject areas, but importantly always in fields and media complementing both the Library's traditional strengths and the interests of the University's faculty, its students, and the scholars who visit the Library's reading room each day. One example can be found in collections that document the avant-garde and counter-cultural movements following World War II, a moment critical to our historical understanding of the second half of the twentieth century. While this emerging area for active collection development might appear a new direction, it builds on the extensive collections of Modernism, Futurism, and Dada developed in the Library's first thirty years. The Beinecke Library looks now, as it has done since its founding, to areas and formats beyond the rare book world's traditional focus. Photographs, posters, maps, and other visual materials have been a particular focus, particularly as they intersect with the written word or complement strengths in areas such as Western American history. Perhaps not surprisingly in a digital age, the Library is acquiring both digital books and archives.

If collections are central to the Library, of equal importance is its mission to describe, preserve, and make them accessible. The Beinecke Library is unusual in combining collections, both broad and deep, with an active program of providing access to a wide audience. The Library sits at the heart of Yale University's campus, and its collections are a landscape where curators, librarians, archivists, faculty, students, researchers, and the general public meet to develop new knowledge, in ways not foreseen when the Library

opened in 1963. In addition to a program of exhibitions and publications, the Library actively participates in the Yale curriculum, as the site of courses and class visits, student projects, and graduate research fellowships. If the Beinecke has been committed to bringing its students into the reading room, to shaping new generations of scholars by welcoming them to the collections, then it has also committed itself to extending this reading room beyond the physical reach of the Library building, in an ambitious program to scan and make its collections available, freely, online. The result is a dynamic institution that supports scholarship both at Yale and around the world.

In the guide to the Beinecke Library's collections published in 1994, Ralph Franklin, then director, noted that "the library's holdings have achieved a depth that makes brief description sound superficial, and a breadth that resists summary." This is even more true today. The items selected for this book provide only the briefest and most tantalizing of introductions to the Beinecke Library collections, one intended as an invitation to explore further in the Library's reading room or through its digital library. To read in these collections, as the title of this book hints, is to be inspired – to fascination, to curiosity, to scholarship. In twenty-five years, the collections will have grown and developed in ways that we do not yet anticipate, but they will continue, as they have in the Library's first fifty years, to inspire all who enter.

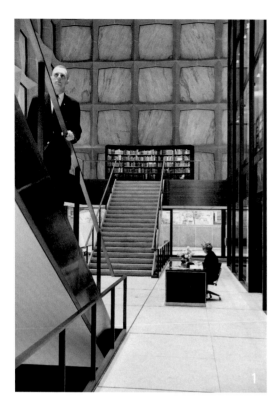

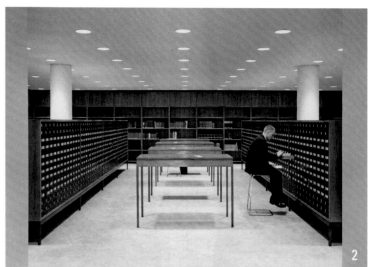

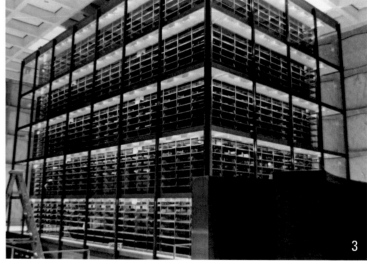

The Laboratory in the Cathedral

An Introduction by Kathryn James

"I happen to love books," Gordon Bunshaft, architect of the Beinecke Library, said years later in an interview on the building, "and I thought it ought to be a treasure house and express that by having a large number of books displayed behind glass." This idea of the treasure house, the display of books behind glass, is nowhere more visible than in the photographs staged of the Library before its opening in October 1963. Here, a young actor—clean-cut, besuited—makes his solitary way through the Library. It is a peregrination that researchers and library staff can still take each day, crossing the Beinecke Plaza— as it has come to be called—to enter the library building. We watch as he climbs the stairs toward the mezzanine, where the collections of the Beinecke brothers were originally displayed, book spines facing out, in the two grand curved exhibition cases built of bronze (fig. 1). He makes his way downstairs to the card catalogs which, in 1963, filled an entire room (fig. 2); here he looks intently through a tray of cards; apparently successfully, as we see him next at a table, alone, peering intently at an eighteenth-century printed volume.

These are misleading images: the solitary researcher, the empty book tower awaiting its stores (fig. 3). Certainly the Library came into being through unquiet spaces, created only through tremendous purpose: a chasm in Hewitt Quadrangle, from which the building emerged, its central supporting structure the elevator shaft around which the book tower was built (fig. 4). And yet there is also a ghostliness to the Library in these images of its construction, an incipient quality to the bare shelves in the book tower, to the air in the spaces to be filled by marble slabs (fig. 5), the steel cube awaiting the granite and marble cladding that would quiet the entire structure with a beauty that still lifts the heart, to see, each day. Like a breath, waiting to be issued into voice, the Beinecke Library rests—in these photographs of its construction, as it has done since—at the heart of Yale University's institutional purpose and campus.

But the glass tower of books—seen precariously ascending in this photograph of the building's elevator shaft—could as easily be read with a different eye (figs. 6 and 7). The tower rising toward the ceiling was not necessarily so different in function from that built by Bunshaft two years earlier in Manhattan, to house the headquarters of Chase

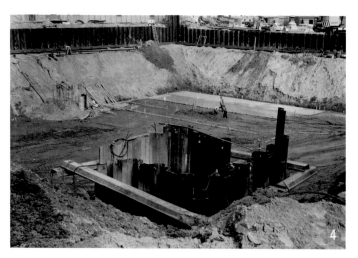

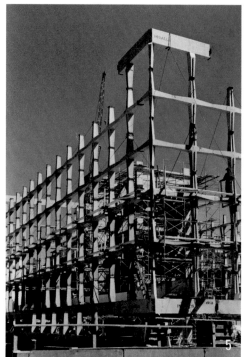

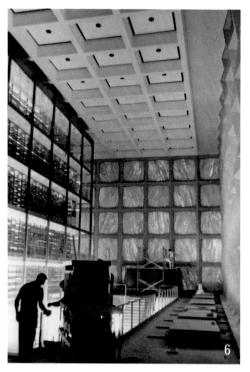

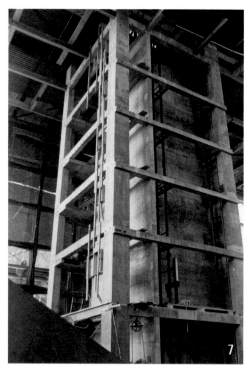

Manhattan Bank: a vast skyscraper clad in aluminum, 1.8 million square feet above the ground and 600,000 below. The Beinecke book tower, as seen here, also reveals part of the Library's real nature. More like a factory tower, a furnace – closer, perhaps even, to the nuclear silos of a Cold War 1963, an era from which the Library takes one of its abiding mythologies – the unfinished book tower, like a machine awaiting its creator, reveals an essential component of the Library's identity: it is a working, mechanical place, the site of great (if changing) technologies, a place more for attention and analysis than for reverence – the laboratory, in short, of the humanities.

And it was always a misleading image: the Beinecke Library was never really empty. The Library takes its place alongside the other rare book and manuscript repositories of Yale University, housing Yale's extraordinary collections. Research Librarian Marjorie G. Wynne can be found in this photograph (fig. 8), as she would through her retirement in 1987, bringing her meticulous attention to bear on the collections transferred to the Beinecke from the Rare Book Room of Sterling Memorial Library. These, which included the holdings of the original Yale College Library, alongside the Yale Collections of American Literature, German Literature, and Western Americana, continue to form the core of the Library's holdings, with the addition in 1974 of the gift, held previously on deposit, of James Marshall Osborn's collection of English literary and historical manuscripts.

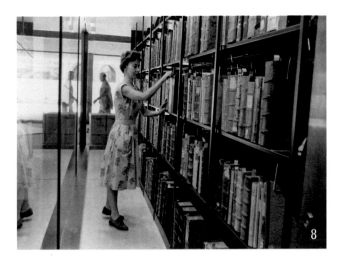

The collections continue to evolve. As anyone who stands in the Library — absorbing the light through the translucent marble, browsing an exhibition in Bunshaft's original cases, visiting the Gutenberg Bible or the elephant folio of John James Audubon's *Birds of North America* — can see, the collections are constantly in motion. Wait long enough, and a member of the library staff will appear in the book tower, wheeling a book truck to collect a book from its place on a shelf, bringing it down the elevator, at the building's core, and to the Library's reading room. This room, airy, encased in glass, opening to the figures of the Sun, Chance, and Time in Isamu Noguchi's sculpture courtyard, sits at the Library's axis, one response always to the question offered by the book tower above (fig. 9).

The Beinecke Library architecture presents us, as it has done since its inception, with the question of what it means for a rare book library to collect for future generations. One answer is offered by the Library's stewards and curators — and by the scholars, students, and faculty who bring these collections into the reading room and the intellectual communities beyond. With tectonic force, these collections move into the reading room and classroom, bearing seismic impact on our understanding of the past. As Frank Turner, then director of the Beinecke, remarked in 2003, the iconic architectural quality of the Library's building can mislead, can lend a mistaken impression of static immobility. The collections, like the ideas of the people who build and use them, are constantly evolving, always in motion.

Named for the presentation inscription on the bronze door into the Beinecke book tower, this anniversary collection opens the laboratory of the Library. These fifty works represent an assemblage of the clamorous voices, the insistences that bring books and manuscripts into the Beinecke collections, the classroom, the reading room. The book begins as the Yale collections began, with a work donated in 1714 to the fledgling Connecticut college by Elihu Yale. In this fifteenth-century English theological work, the *Speculum humanae salvationis,* one of the book's many readers, Yale College President Ezra Stiles, can be found observing what countless Yale students have done since (but perhaps not in the margins of the Library's books): "perlegi hunc librum," or, "I read this book."

The works that follow bring the Beinecke Library collections to the reader as they might be found in a single day — even a single morning — in the Library's reading room, paged from the book tower and the stacks for scholars and for classes. Shifting

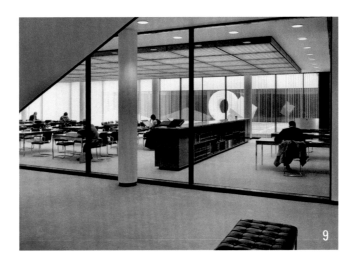

across geographical and chronological boundaries, these works include some that were already part of the Library collections in 1963 – manuscript notes from the Lewis and Clark expedition, seen here as in the portrait, facing the Library's reading room, of the Beinecke brothers – and some of the most recent additions to the collections. Here the poem-paintings of Susan Howe precede the manuscript and first printed edition of Jonathan Edwards's *Sinners in the Hands of an Angry God,* an archive which has informed Howe's creative work, including her Bollingen Prize winning book, *That This* (2010). Here Alexander Gardner offers his photographic landscape of the American Civil War, in a work as carefully constructed, as critically important, as German novelist Grimmelshausen's own commentary on warfare, the *Trutz Simplex* (1670), the source, in 1939, for Bertolt Brecht's *Mother Courage and Her Children.* Here John Hancock can be found practicing his signature, in a manuscript that testifies to the fragile, the improbably retained nature of our historical record, as does a tenth-century copy of the New Testament, bound and re-bound by later owners and passing to the Yale collections from those of the General Theological Seminary.

The continued power of the Beinecke's foundational collections can be seen in the Phillis Wheatley poems and Carl Van Vechten photographs in the James Weldon Johnson Memorial Collection, as in the recent addition to the James Marshall and Marie-Louise Osborn Collection of some forty years of daily journals kept by Thomas Thistlewood,

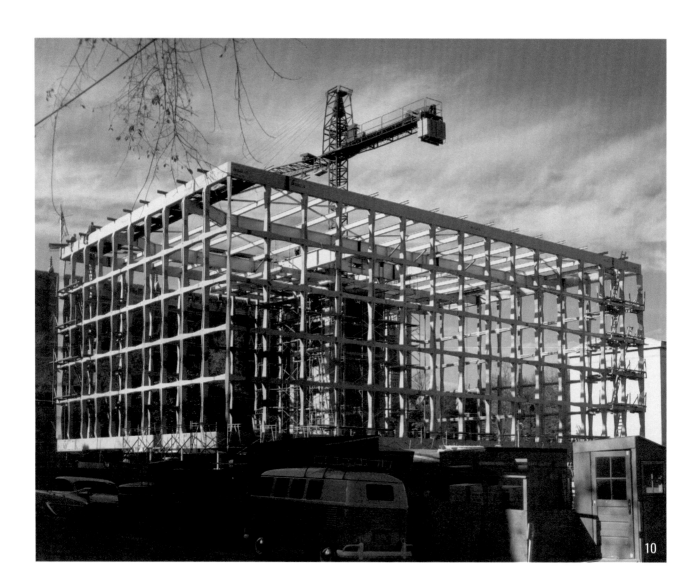
10

eighteenth-century British planter in Jamaica. The life in these objects still crackles from the page: William Morris's annotations to the chilly Modernist beauty of the Kelmscott Chaucer make audible his electric, irascible presence; Pablo Picasso still laughs to his friends Gertrude Stein and Alice B. Toklas in the fabric he designed for two diminutive chairs. The artist Tamar Stone's 2004 commentary on the de-humanization of the individual can be found here alongside Siegfried Sassoon's denouncement, in his extra-illustrated copy of *Goodbye to All That,* of his erstwhile friend Robert Graves's eviscerating memoir of World War I. Stone, Sassoon, Graves: these and others here stand alongside Holocaust survivor Henri Chopin as he grapples with the poetics of sound and memory, as does the scribe in the second-century Roman Empire, recording musical notation for two songs which, if ever sung, are now found only in this scrap of papyrus.

Captured in photographs, these works are brought from the collections to the reader as physical artifacts, in print and manuscript, the objects underpinning our always shifting readings of the "texts" or meanings of the past. The collections recall us to an understanding of the ephemerality of our own moment, of its historical and emotional complexities, of our obligation as readers and critics to pay attention, to remember, to enter into the reading room.

Having begun where the collections began, the book ends with a work chosen by the Library's readers. In a public vote, Yale faculty and students, the Beinecke Library staff, and the Beinecke's broader audiences selected the prayer book annotated by Sir Thomas More as the fiftieth object to be included in this book. The prayer book was with More in the Tower of London, where he was held by Henry VIII for almost two years before his beheading on July 6, 1535. "Give me thy grace, good Lord," he wrote, around a woodblock illustration of Mary, "to set the world at nought." Like each of the works shown in this collection, this book captures a moment in our historical record, one from which a particular reader, a particular writer, speaks to us across the distances of time. The Beinecke Library collections, here as each day in the Library's reading room, summon us to listen, to bring our attention — as readers, as students, as stewards — to this record of our humanity. As its architect once said of the Beinecke Library: "It's the only building I've been involved in that has an emotional impact." (fig. 10)

Fifty Works

IN 1714, ELIHU YALE gave the new Collegiate School of Connecticut a copy of the *Speculum humanae salvationis,* or Mirror of human salvation, a fifteenth-century English theological text and the first illuminated medieval manuscript known in a North American collection. With the thirty-one other works given by Yale to the fledgling college, the manuscript followed the fortunes of the new college library, moving from its early home on the second floor of the original Yale College building at the corner of College and Chapel streets, to the first library building of 1842 in what is now Dwight Chapel, through the magnificent Gothic cathedral opening in 1931 to house the Yale University Library collections. In 1963 the book made its most recent journey, across Wall Street to the empty shelves of its new home, the Beinecke Rare Book and Manuscript Library. Since then, it has traveled from the library stacks into the reading room, the classrooms, the digital studio, where it has been scanned in its entirety, and into the bronze exhibition case facing out across Hewitt Quadrangle towards Woodbridge Hall and Sterling Memorial Library, as the first book in an exhibition on the manuscript collections to celebrate the fiftieth anniversary of the Beinecke Library.

The deceptive simplicity of the book's materials mirrors that of the library in which it is now housed. Sheets of parchment, now worn; ink and pigments used by the fifteenth-century English scribe to write and illustrate the text; beech boards; a soft pigskin binding swaddling the manuscript; the stitching, pegs, and thongs used to bring the leaves of parchment and text together into a bound, coherent book. Its history can be found, as well, inscribed upon its pages. Someone has, in proprietary fashion, written "Yale College Library 1715" on the book's front cover. And on January 26, 1793, Ezra Stiles, graduate of the Yale class of 1746 and President of Yale College, wrote "perlegi hunc librum," or, "I read this book," in its margin.

Readers in the Beinecke collections are not encouraged to write in the margins of the Library's books. But, as Stiles can be seen observing in 1793, the books in the Library's collections are there to be read. The manuscript was already some two hundred years old when it was donated to the new Yale College Library by its patron, Elihu Yale. Since then, generation upon generation of scholars, students, and librarians have joined Stiles in his study of the collections, noting (perhaps not in the margins) that they, like he, had read this book.

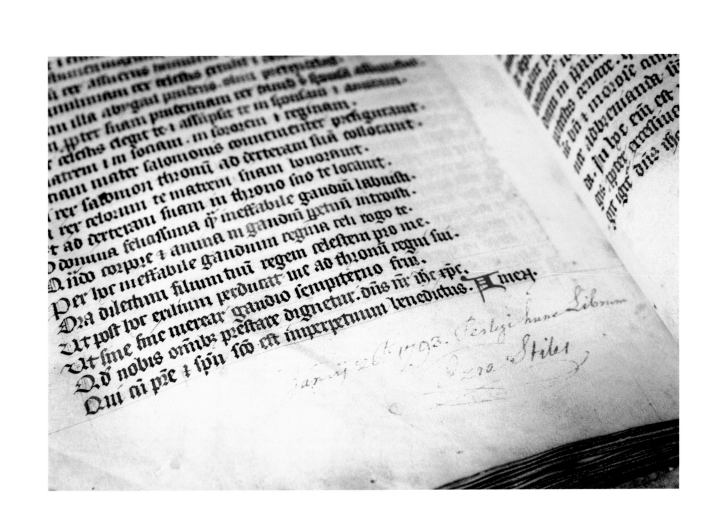

TIR À CIBLE ("shooting targets") consists of a single pair of small accordion-folded sheets. The words are printed using blueprint technique on paper, and the story is basic — the joys of a country fair and the amusements found there: "…the target shoot where I never win because my hand trembles just as I am about to pull the trigger…" until "I invent a target shoot with monsters, so I won't have to shoot at doves, men's hats and rabbits…" The images on the second folded sheet — of these monsters, under fire — are printed in bright colors on pieces of very thin wood veneer, by printing blocks that lend the impression of having themselves been shot through by bullets.

The book — an example of the twentieth-century artistic movement Art Brut — contributes to an extraordinary record of ideas of the modern, as expressed in print and manuscript through the present day. The Beinecke Library collections document movements in modern art, and the literary movements, particularly those such as Dada, Futurism, Vorticism, and Surrealism, that sought to expand the definitions of creative artistic practice. Along with collections of books that document these movements, the Library holds archives and resources on the visual work that embodies their philosophies and techniques.

More recently, the Library has begun to document more and more varied schools of artistic expression, from COBRA to Fluxus to Stamp Art. The work of Jean Dubuffet, founder of the Compagnie de l'Art Brut, provides a view into one of the most deceptively simple movements in the second half of the twentieth century. In addition to his expressive paintings and sculptures, Dubuffet wrote constantly about his view of art in the lives of ordinary people. He officially established Art Brut as an entity in 1948, with the intent of marking the event by having a small series of books produced to exemplify the aims of the group. Slavko Kopač, a Croatian-born artist, served as the company's director, secretary, curator, and archivist. His contribution, created in 1949, is perhaps one of the purest expressions of the Art Brut aesthetic.

A small, delicate thing, *Tir à cible* performs its function as a piece of evidence of the early days of what would come to be seen as a significant art movement. It is a self-contained moment of invention, of very simple hand-made printing techniques, and of a memory of the games we used to play.

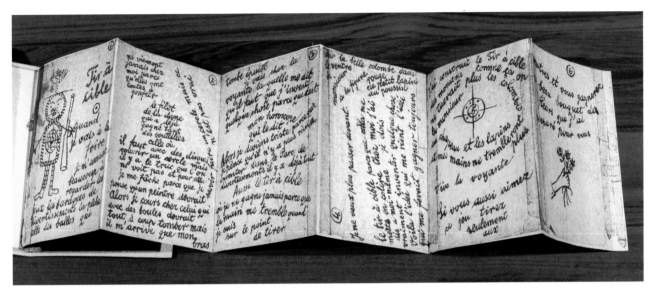

Phillis Wheatley, *Poems on Various Subjects, Religious and Moral, By Phillis Wheatley, Negro Servant to Mr. John Wheatley, of Boston, in New England.* London: Printed for A. Bell, bookseller, Aldgate; and sold by Messrs. Cox and Berry, King-street, Boston, 1773. Yale Collection of American Literature

BORN IN AFRICA, Phillis Wheatley was kidnapped by slave traders as a child and sent to Boston on a slave ship in 1761. There she was purchased by a tailor named John Wheatley as a house servant. The Wheatley family taught Phillis to read and write and encouraged her interest in poetry. With the Wheatley's daughter Mary as a teacher, Phillis soon mastered English, Greek, and Latin. As a teenager, she began writing poetry, most of which concerned religious subjects. Her first book of poems was published in England in 1773. After the success of her writing, Wheatley was eventually emancipated. An American edition of *Poems on Various Subjects, Religious and Moral* was published in 1789, five years after Wheatley's death. Two additional books of poems and letters were posthumously published in the nineteenth century.

The James Weldon Johnson Memorial Collection of American Negro Arts and Letters includes various early British and American printings of the work of Phillis Wheatley, among an extraordinary collection of printed books and ephemera by African American writers. As they have since the collection was founded in 1950, curators continue actively to build the collection, adding hundreds of titles every year; today the James Weldon Johnson Memorial Collection includes more than 20,000 printed works by African American writers.

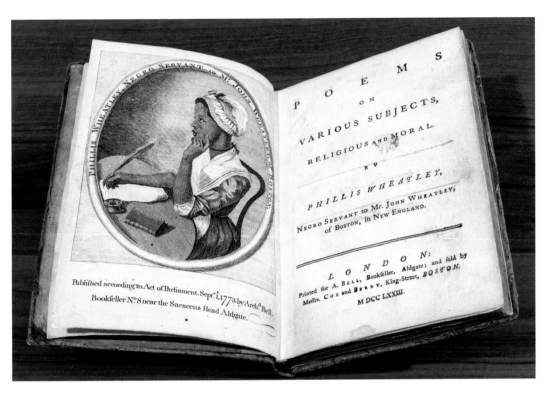

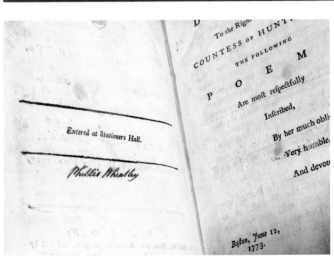

THE MOST FRAGMENTARY and ephemeral of songs survive on this scrap of papyrus from the second-century Roman Empire. The scribe has copied two poems—in melic verse, or verse intended to be sung—possibly addressed to the gods Apollo and Artemis. Above the letters, musical notation guides a performance for an audience that lived and died almost two thousand years ago. It survives for us on a writing medium made from the leaves of *Cyperus papyrus,* a wetland sedge, used for over five thousand years to record human thought.

Papyrus has its own history in the Yale University Library collections. Only a few months after it had opened, the Beinecke Library received the gift of some two hundred papyrus fragments, the purchase by Edwin J. Beinecke of an entire catalog issued by the rare book dealer H. P. Kraus. The Yale University papyrus collection had itself originated in 1889, with the donation of three fragments by Jesse Haworth, a merchant in Manchester, England, and avid supporter of Egyptology. The current collection, several thousand items strong, ranges from scraps used in the third century B.C.E. in the papier-mâché to make mummies, to fragments of the Nag Hammadi Codex III, to these efforts by a student, copying the lines of a Euripides play in the third century B.C.E., cited here from an essay and exhibition in 1989 by Stephen Emmel: *"Many are the forms of what is unknown. Much that the gods achieve is surprise. What we look for does not come to pass. God finds a way for what none foresaw. Such was the end of this story."*

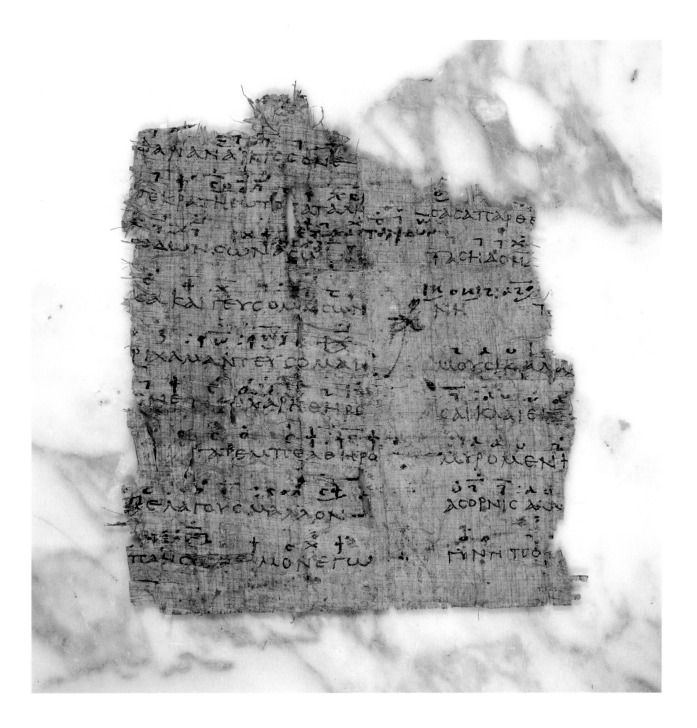

WINNER OF THE 2011 BOLLINGEN PRIZE for Poetry, Susan Howe is among the most influential poets of her generation. Her training as a painter—Howe studied at the Boston Museum School of Fine Arts in the 1960s—is evident in the poet's archive; the Susan Howe Papers in the Yale Collection of American Literature include rare transitional works from the period when Howe moved from the canvas to the page.

Experiments with color, collage, and text, these early works occupy a space between painting and poetry. These two examples, completed just a few years before Howe's first book of poems was published, anticipate the revolutionary textual experiments for which the poet is now renowned.

In her recent writings, Howe continues to cross the boundaries of genre and to combine textual and visual elements. Often drawing on historical and archival sources, Howe's Bollingen Prize-winning volume, *That This,* includes quotations from unique documents in the Beinecke's collections; the book's cover bears an image of a small square of blue cloth, a fragment of the wedding dress of Sarah Pierpont Edwards, from the Jonathan Edwards Papers.

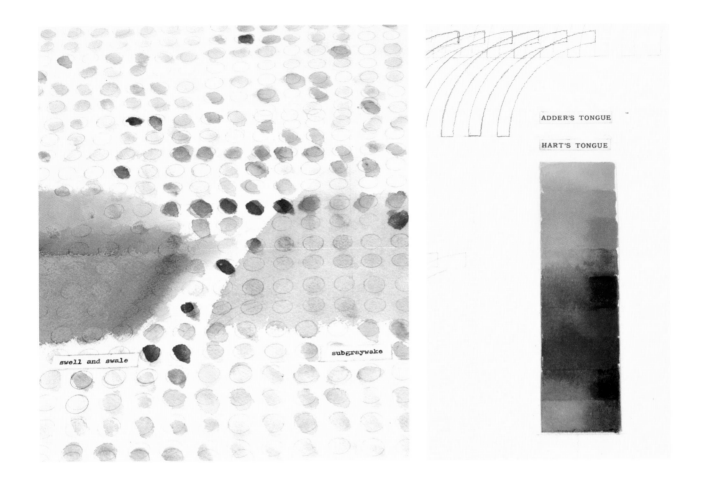

swell and swale

subgraywake

ADDER'S TONGUE

HART'S TONGUE

Jonathan Edwards, Manuscript notes for a sermon on Deuteronomy 32:35: "There is nothing that keeps wicked men at each moment out of hell but the meer pleasure of God" (Delivered at Enfield, Connecticut, 1741). Jonathan Edwards Papers, General Collection

Sinners in the Hands of an Angry God. A Sermon Preached at Enfield, July 8th 1741. At a Time of Great Awakenings; and Attended with Remarkable Impressions on Many of the Hearers. Boston, 1741. General Collection

JONATHAN EDWARDS DELIVERED thousands of sermons during his life, but he is best known for his ruminations on Deuteronomy 32:35 – "in due time their foot will slip." He first spoke on the text to his church in Northampton, Massachusetts, in June, 1741. By July 8, when he traveled to preach before the notoriously skeptical congregation at Enfield, Connecticut, Edwards had crafted one of the most powerful sermons of his career, a sermon whose imagery and theology captured and sustained the Great Awakening that reshaped life in eighteenth-century New England.

A precocious student, Edwards had graduated from Yale College in September 1720 as valedictorian. Deeply interested in science, he regarded the natural world as a sign of God's masterful design and omnipresence. The power of *Sinners in the Hands of an Angry God* derives from his use of common, familiar imagery of the everyday world to convey his theological convictions about humanity's depravity and the reality of Hell, as well as the power and mercy of God's grace.

Edwards preached from a tiny packet of notes that fit in the palm of one hand. Contemporary accounts report that he delivered the sermon without theatrics and without raising his voice, but his audience was so overcome emotionally that he could barely be heard by the end of the sermon.

Awareness of the sermon spread rapidly. Boston printers Stephen Kneeland and Timothy Green, who had traced the revival of religion in their newspaper, *The Boston Gazette*, quickly arranged to print Edwards's sermon as a small, inexpensive chapbook, which they reprinted the following year. Despite the availability of the text, congregations throughout New England wanted to hear as well as read Edwards's words. He was asked to re-preach the sermon so frequently that he was soon able to speak almost entirely from memory, with only a small outline to guide him. Today we can contemplate what he said, but only imagine how he sounded.

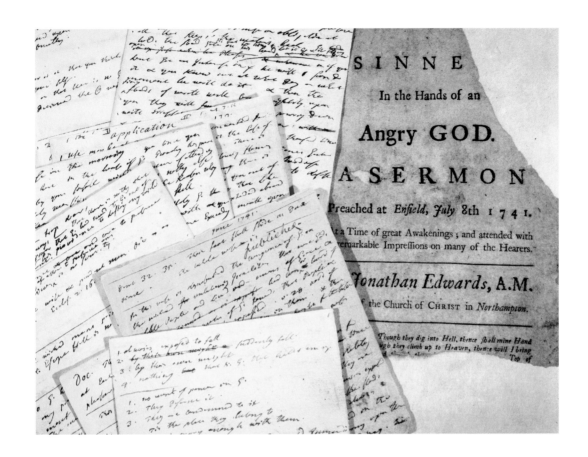

"I INTEND TO EDIT A SPLENDID BULLETIN, on the meanest paper that exists, but still very modern," Theo van Doesburg wrote to the Dutch poet Anthony Kok, announcing the birth of *Mécano* in February 1921. "If you happen to have a spiritual Dadaist piece, do send it to me for this bulletin."

By the time the first number appeared, Doesburg had made at least some concession to appearances. Each of the first three issues (all 1922) came out on glossy white paper, a single sheet folded into eight panels per side, the versos printed successively in the bright primary colors — blue, yellow, and then red — that were a staple of Doesburg's more famous (and mainstream) magazine, *De Stijl.* Apart from that, however, the two serials appeared to have little in common: *De Stijl* crisp, sober, regimented, devoted to Doesburg's "utilitarian" approach to typography; *Mécano* a wild romp of Dadaist deconstruction.

Doesburg's alter ego, "I. K. Bonset," appears on the masthead as "literary manager," the designer's name listed second, in a capacity of diminished responsibility, as the bulletin's "plastic mechanic." Although printed by *De Stijl, Mécano* was a quasi-sub-rosa publication, at least at first, and many have argued that Doesburg intentionally concealed his role for fear of undermining support for his more "serious" efforts. Yet it was precisely Doesburg's openness for the countering impulses of Dada that saved *De Stijl* (and many another high modernist enterprise) from the kind of one-dimensional focus on discipline, clarity, rationality, and control that has often been taken as the essence of Modernism and its legacy.

In *Mécano* one finds a masterpiece of the finely executed contradictions that fuelled avant-garde typographic innovation from the early 1920s on.

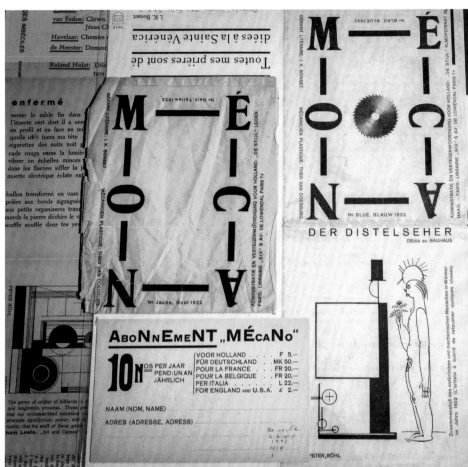

IN 1839, THE SPANISH SLAVE SHIP *AMISTAD* set sail from Havana to Puerto Príncipe, Cuba. The fifty-three Africans aboard the ship had, months earlier, been abducted from their homeland to be sold as slaves. They revolted against the ship's crew, killing the captain and others, but sparing the life of the ship's navigator so that he could set them on a course back to Africa. The navigator surreptitiously directed the ship north and west. Weeks later, the *Amistad* was seized by the United States Navy off the coast of Long Island; the Africans were transported to New Haven to await trial for mutiny, murder, and piracy.

Slavery advocates held that the *Amistad* prisoners were slaves and thus should be punished for their uprising. Abolitionists argued that though slavery was legal in Cuba, the importation of slaves from Africa had been outlawed; the prisoners, they claimed, were not slaves, but freemen who had been kidnapped and thus had every right to escape their captors. The case was important to the proslavery-abolitionist debates that were raging in the United States, and to the international debates about treaty obligations with regard to slavery and the legality of the international slave trade. After two years of legal battles, their case was successfully argued before the Supreme Court in 1841 by former President John Quincy Adams, and the *Amistad* captives were freed. They returned to Sierra Leone in 1842.

New Haven resident William H. Townsend made pen-and-ink sketches of the *Amistad* captives while they were awaiting trial. Townsend, who was about 18 years old when he made the drawings, is buried in the Grove Street Cemetery.

9

Voynich Manuscript. Central
Europe? Fifteenth century?
General Collection

But Dan had moved toward the railing of the mezzanine and was staring at the glass tower.
"Hey," he called softly to the others. "The Voynich — do you think it's somewhere in there?"
— Linda Sue Park, *Trust No One* (New York: Scholastic, 2012)

THE BEINECKE LIBRARY draws scholars from around the world for research in collections of extraordinary range and depth. Among these, one manuscript is perhaps the most famous, even notorious. The subject of several documentaries, of young adult and graphic novels, of its own thriving internet community, and of countless theories on its origin and meaning, the Voynich Manuscript remains an enigma.

Presented to Yale University by H. P. Kraus in 1969, the manuscript continues to stymie all attempts to decipher what seems to be an encrypted language, in an illustrated manuscript which carbon dating has indicated as of the fifteenth century. For centuries, the manuscript has fascinated its audiences: from Marcus Marci, seventeenth-century Jesuit, sending the manuscript to his colleague, the linguist Athanasius Kircher, in hopes that he might be able to translate it, to the present day, and authors like Linda Sue Park, whose characters in her novel for the 39 Clues series continue their quest to decode the manuscript's secrets.

The Voynich Manuscript has been rescued (fictionally) by a superhero; it has been stolen (fictionally) on many occasions; it has been studied by United States Navy cryptographers; it has been set to music; it has been filmed; it has, not least, been analyzed through carbon dating and pigment testing by forensic archaeologists; it has not been deciphered.

On the manuscript's origin and meaning, the Beinecke Library joins Marci, in his letter of 1666 to Kircher: "On this point, I suspend judgment."

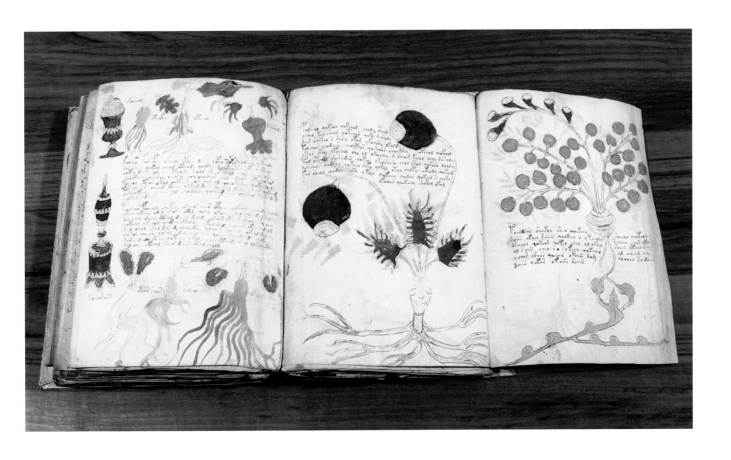

10

The Codex Reese.
Mexico City, ca. 1565.
Yale Collection of Western
Americana

ONE OF THE OLDEST MAPS of any portion of Mexico City, the Codex Reese was crafted by indigenous cartographers in the middle of the sixteenth century. It asserts the claim of individually named Native Americans to land and irrigation rights in a neighborhood of Mexico City, formally the Aztec capital of Tenochtitlan.

The map depicts Luis de Velasco, Count of Santiago and the second Viceroy of New Spain, as well as five native "governors" who helped the viceroy administer Mexico City from 1538 through 1565. It records the owners of 121 individually marked parcels of land and the crops they grew—whether the highly cultivated food stuff maize or the semi-wild reed *tule* that was used in building and as forage for Spanish horses and cattle. It marks the location of a Catholic Church along the dike that held back the brackish water of the lake that once surrounded Tenochtitlan as well as citrus orchards and foot paths through parts of the city.

Revised multiple times, reflecting changing circumstances within New Spain, the map is the work of multiple craftsmen. Scholars have identified as many as six artistic hands at work in different portions of the map. They have also isolated strips of *amate* (fig-bark paper) that were clearly spliced to the map after its initial creation. While its makers remain unidentified, the map reveals much about pre-Columbian artistic practices as well as the ways in which Aztec nobles and commoners navigated Spanish rule in the decades after Cortes conquered Mexico.

The Beinecke Library acquired the map in 1975 from a Yale undergraduate, William Reese, then just beginning his career as an antiquarian bookseller. In 2012, the Library sponsored the publication of *Painting a Map of Sixteenth-Century Mexico City: Land, Writing and Native Rule,* a report of investigations into the map by an international team of scholars led by Yale Professor Mary E. Miller and Barbara E. Mundy of Fordham University.

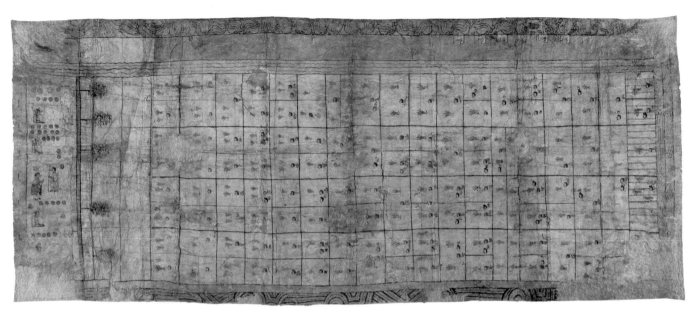

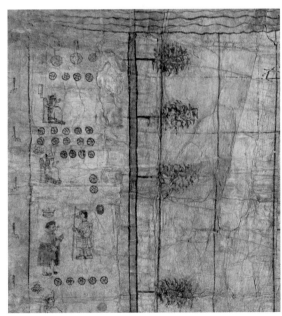

11

Manuscript drafts and notes
by Walt Whitman. Walt
Whitman Collection, Yale
Collection of American
Literature

THE YALE COLLECTION OF AMERICAN LITERATURE was formed in 1911 when Owen F. Aldis donated his collection of first and other notable editions by American writers of belles lettres. Aldis, who graduated from Yale in 1874, began collecting books around 1890, acquiring primarily American first editions and aiming to include in each volume a letter from the author referring to the specific title. Since its founding, the Yale Collection of American Literature has been maintained as a separate entity with its own curators. Noted for its bibliographic strength in nineteenth- and early twentieth-century writings, the collection includes first and other significant editions of virtually every major work of American literature published by prominent authors of the period, often in copies of distinguished provenance, such as Henry David Thoreau's inscribed copy of Ralph Waldo Emerson's *Essays*. The work of James Fenimore Cooper, Washington Irving, and Henry Wadsworth Longfellow are represented in books and manuscripts, as are mid-century greats associated with Transcendentalism and the so-called American Renaissance: Emily Dickinson, Mark Twain, and Harriet Beecher Stowe. The writers of the nineteenth century helped to shape a uniquely American literature, exploring a range of literary styles and considering specifically American subject matter.

An example of the collection's great strength in nineteenth-century printed, manuscript, and visual materials documenting American literature is its outstanding holdings relating to the life and writing of Walt Whitman. In addition to distinguished copies of all of Whitman's published works (including five copies of the extraordinarily rare first edition of *Leaves of Grass*, published in 1855), the Whitman collection contains letters, manuscripts, photographs, art, and other material dating from 1842–1949, and features the Whitmania of Yale benefactors Owen F. Aldis, Louis Mayer Rabinowitz, and Adrian Van Sinderen, among others. "How dare one say it?" Whitman writes, in this manuscript of the poem "The Unexpress'd," in one of the many original, corrected drafts in his hand in the Beinecke Library collections:

After the good songs, or long or short, all tongues, all lands,
Then something not yet put in poesy's voice or print — something lacking,
(May be the best yet unexpress'd and lacking.)

In St. John's Reprints
(in Critic 16 aug)

CAMDEN N.J.
1 30 PM
AUG 4
90

Walt Whitman's
A New Book
by Walt Whitman

Memoranda of a ramble —

The Unexpress'd.

Oct 1st '90

rejected
all returned

How dare one say it?
After the cycles, poems si...

¶ No great poem (or other literary or artistic work) old or new, can be
essentially consider'd without weighing first the ...
... politics (the want of politics)

in Poetry of The Future

And As that individual only becomes truly
great by who understanding well that he is ...
while complete in himself in a certain sense

No obstinate
Gloomy ashes worthy
As I Sit Thinking Here

For me, as I sit here thinking there, gra...

Folding merchant's calendar.
Paris, ca. 1290–1300.
General Collection

IT IS THE MOST NECESSARY BOOKS, carried by their readers through their daily lives, that are often the most rare, the least likely to survive. Beinecke MS 923 is one example of this, a thirteenth-century *vade mecum* (literally, "bring with me"), a not uncommon type of document, designed to be worn about the body, carried from place to place. Several folios were written on and then folded neatly and gathered together. A string was attached to the gathering, the whole given a cover and suspended from a belt. Alternatively, such manuscripts could be carried in a pouch.

Most surviving manuscripts of this type are identifiably medical in nature. Medieval physicians often carried charts that indicated the best times and the proper veins for bleeding a patient; a diagram of a Zodiac Man might also be included, showing the effects of planetary bodies on specific organs, such as the effect of the moon on the brain. It was also common to include a chart for diagnosing illness by observing the patient's urine.

While it is unusual for any manuscript designed to be carried in this way to survive from the medieval period, this one is in particularly good condition: all the original leaves are extant and it is still in its leather case, with textile cover (once a deep red color, now faded to light pink). There are a total of twenty-seven individual strips of vellum that make up the manuscript. In these, MS 923 shares some elements with the medical *vade mecum,* such as a calendar for inauspicious days, called Egyptian Days or perilous days. While a physician would use these to determine when best to bleed a patient, such a listing of days could have been used to determine when to set out on a journey or when to commence a new business. Indeed, the contents of this manuscript suggest that it was designed for use by a merchant rather than a doctor. For example, there is no Zodiac Man, nor are there charts for bleeding; in their place is a calendar of fair dates in Champagne. More puzzling is that several of the folios contain religious texts, such as extracts from the Book of Genesis and Ezekiel and a list of the twelve Fridays on which the Apostles prayed with the Jesus. The final six folios contain a list of the generations commencing with Abraham and extending to Jesus.

With its collection of inauspicious days, biblical and devotional texts, and local fair dates, this *vade mecum* reveals its owner to have been a careful, perhaps somewhat superstitious yet extremely pious merchant who took very good care of his traveling book.

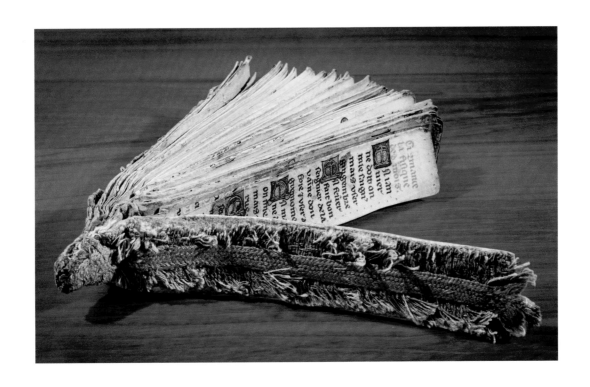

THE GENESIS OF MODERN TEXAS is documented in this broadside, the only surviving copy of Stephen Austin's announcement that the revolutionary government of Mexico would sustain the colonization agreement that his father had made with Spanish officials.

In December 1820 the Spanish governor of Texas, Antonio María Martínez, endorsed a proposal by Moses Austin to establish a colony of three hundred families in Texas. As Moses returned to the United States to recruit settlers, he contracted pneumonia. Before he died, he persuaded his son Stephen to pick up "the Texas venture." Under Stephen's leadership, colonists began to arrive in Texas in December 1821, only to learn that the provisional government established after Mexican independence had refused to approve the Spanish grant. Austin rushed to Mexico City where, after months of negotiations, he convinced Agustín de Iturbide's rump congress, the *Junta Instituyente,* to enact a colonization law that the emperor signed on January 3, 1823. The law was annulled by Iturbide's abdication in March, but a month later a new government issued a special decree applying the law's terms to Austin's colony.

When Austin returned to Texas in late June 1823 the population of his colony had fallen and its success seemed doubtful. To strengthen the resolve of the remaining settlers and to recruit new families, Austin published a broadside recounting the success of his mission to Mexico City and the terms under which Anglo-American settlement of Texas would be permitted. In doing so, he took advantage of the first officially sanctioned printing press to operate within the boundaries of modern Texas.

When the revolutionary José Félix Trespalacios was appointed Governor of Texas in 1822, he commissioned an aide to purchase a printing press in the United States. In late January or early February of 1823, the press arrived in San Antonio, where it was employed for six months before the government moved it to Monterey, Mexico. In July, weeks before the press was transferred, Austin paid to have it print his broadside, which has survived only in this proof copy, corrected by his hand. It would be more than five years before another printing press came to Texas.

The famed bibliographer Thomas Streeter acquired Austin's announcement from Charles Everitt, who found it and other early Texas broadsides among a lot of Texas newspapers that he had purchased at auction. It came to the Beinecke Library as part of Streeter's extraordinary Texana collection.

To the settlers in Austins settlement.

FELLOW CITIZENS,

After an absence of sixteen months I have the pleasure of returning once more to the settlement which it has been the labor of the last three years of my life to establish in the unsettled deserts of this province. Nothing but the interest of the settlers, and the general welfare of the settlement could have induced me to make the sacrifices of time, of fatigue, and money, which this enterprize has cost me; but feeling in honor bound never to abandon those who had embarked with me, and animated with the hope of rendering an important service to the great Mexican nation, and particularly to this Province, by the formation of a flourishing colony within its limits, I have persevered through all the difficulties created by the political convulsions of the last year, and now have the satisfaction of announcing that every necessary power relative to the formation of the colony is granted to me by the Supreme Executive power and Sovereign Congress of Mexico; and that I shall immediately commence in conjunction with the Baron de Bastrop, the governmental Commissioner appointed for this purpose, to designate the land for the settlers, and deliver complete titles therefor.

It will be observed, by all who wish to be received into this colony, that the conditions indicated by me in the first commencement of the settlement must be complied with, and particularly that the most unquestionable testimony of good character, and industrious and moral habits will be required. No person can be permitted to remain in the settlement longer than may be absolutely necessary to prepare to prepare for a removal who does not exhibit such testimony. This regulation is in conformity with the orders of the Superior Government, and will be enforced with the utmost rigour.

Being charged by the Superior Government with the administration of justice, the punishment of crimes, and the preservation of good order and tranquility within the settlement, it will be my study to devote that attention to those subjects which their transcendant importance requires, and I confidently hope that, with the aid of the settlers we shall be able to present an example of industry and good morals equally creditable to ourselves and gratifying to the government of our adoption.

The Alcaldes appointed on the Colorado and Brazos in the month of November last will continue to exercise their functions until the year for which they were elected expires, at which time a new election for those officers will be ordered. The administration of justice by the Alcaldes will be subject to my inspection; and appeals from their decisions will be decided by me. Fixed regulations will be established on this subject, and made known to the settlers as soon as time will permit.

I beg every individual in the establishment to be impressed with the important truth that his future prosperity and happiness depends on the correctness of his own conduct. Honest and industrious men may live together all their lives without a law-suit or difference with each other. I have known examples of this kind in the United States: so it must be with us—nothing is more easy: all that is necessary is for every one to attend industriously to his own business, and in all cases follow the great and sacred christian rule, *to do unto others as you wish them to do unto you.* As regards the suppression of vice and immorality, and the punishment of crime, much depends on yourselves. The wisest laws and the most efficient administration of justice, in criminal cases, avails but little, unless seconded by the good examples, patriotism and virtues of the people. It will therefore be expected that every man in the settlement will at all times be willing to aid the civil authority whenever called on to pursue, apprehend or punish criminals, and also, that the most prompt information will be given to the nearest civil officer, of any murder, robbery, breach of the peace, or other violation of the laws.

Being also charged with the Commission of Lt. Colonel Commandant of the Militia within the settlement, I shall, as soon as possible, organize a battalion of militia, in which every man capable of bearing arms must be enrolled and hold himself in readiness to march at a moment's warning, whenever called on to repel the attacks of hostile indians or other enemies of the Mexican nation.

I am limited to the number of 300 families for the settlement on the Colorado and Brazos. The government have ordered that all over that number who are introduced by me, must settle in the interior of the province, near the ancient establishments.

As soon as the necessary information can be procured, a town will be established as the capital of the settlement, and a port of entry will be designated on the coast for the introduction of all articles required for the use of the settlers. All town scites are reserved, and no person will be permitted to locate them.

Fellow Citizens, let me again repeat that your happiness rests with yourselves; the Mexican Government have been bountiful in the favors and privileges which she has granted to the settlement, in return for which all she asks is that you will be firm supporters and defenders of the Independence and Liberty of the Mexican Nation; that you should industriously cultivate the soil that is granted you, that you should strictly obey the laws and constituted authorities, and in fact, that you should be good citizens and virtuous men.

STEPHEN F. AUSTIN

Province of Texas, July, 1823.

Álvar Núñez Cabeza de Vaca, *La relacion y comentarios del gouernador Aluar nuñez cabeça de vaca.* Valladolid, 1555. The Henry C. Taylor Collection, General Collection

THIS MEMOIR by a would-be conquistador who learned humility and compassion as he and three companions survived the first American "road trip" is the earliest published work to describe people and places in what became part of the United States.

Álvar Núñez Cabeza de Vaca was born around 1490 to hidalgo parents. In the winter of 1526–27, he was appointed treasurer for Pánfilo de Narváez's expedition to Florida. On April 15, 1528, six hundred men arrived at Tampa Bay, where Narváez decided to march overland in pursuit of wealth. He sent the ships "ahead," but the two portions of the expedition never reunited. By summer's end, Narváez's men were starving. They built five simple ships, hardly more than rafts, each of which could carry fifty men. They sailed along the Gulf coast, hoping to reach Mexico, but when they crossed the mouth of the Mississippi River, the current scattered the ships into the Gulf. A hurricane destroyed three of the craft and cast two ships, including one commanded by Cabeza de Vaca, ashore on Galveston Island. As the men attempted to repair the ships, large waves swept the rafts away. Within a short time only four men from the original expedition, Cabeza de Vaca, Andrés Dorantes de Carranza, Alonso del Castillo Maldonado, and an enslaved Moroccan Berber named Esteban survived.

Taken captive by local Indians, the four men traveled through what are today southern Texas, Tamaulipas, Nuevo León, Coahuila, and possibly portions of New Mexico and Arizona. During their travels, Cabeza de Vaca earned a reputation among the Indians as a healer—a trait he ascribed to Christ's intervention on his behalf. Over time, he and his companions gathered a following of Native Americans who regarded them as "children of the sun." At the same time, Cabeza de Vaca developed a great sympathy for and under-standing of the people among whom he traveled. His account remains a valuable descrip-tion of their material culture and social organization.

Cabeza de Vaca's traveling medicine show eventually reached the Gulf of California. In July 1536, nearly eight years after washing ashore in Texas, he and his companions encountered Spaniards near Culiacán, in present-day Sinaloa. A year later he sailed back to Spain where he completed his *Relacion*. First published in 1542 (of which only three copies survive), it remains an epic of early American exploration and personal transformation.

Mas como ni mi consejo ni diligencia aprouecharon para
que aquello a que eramos ydos fuesse ganado conforme al
seruicio de vuestra magestad, y por nuestros peccados per
mitiesse dios que de quantas armadas a aquellas tierras han
ydo ninguna se viesse en tan grandes peligros ni tuuiesse tan mi
serable y desastrado fin, no me quedo lugar para hazer mas
seruicio deste, que es traer a vuestra magestad relacion de lo
que en diez años que por muchas y muy estrañas tierras que an
duue perdido y en cueros, pudiesse saber y ver, ansi en el sitio
delas tierras y prouincias y distancias dellas, como enlos man
tenimientos y animales que en ellas se crian, y las diuersas
costumbres de muchas y muy barbaras nasciones con quien
conuerse y vini, y todas las otras particularidades que pude
alcançar y conoscer, que dello en alguna manera vuestra ma
gestad sera seruido: porque aun si la esperança de salir den
tre ellos tuue, siempre fue muy poca, el cuydado y diligencia
siempre fue muy grande de tener particular memoria de todo
para que si en algun tiempo dios nuestro señor quisiesse traer
me a donde agora estoy, pudiesse dar testigo de mi voluntad
y seruir a vuestra magestad. Como la relacion dello es auiso
a mi parescer no liuiano, para los que en su nombre fueren a
conquistar aquellas tierras: y juntamente traer los a conosci
miento dela verdadera fee y verdadero señor, y seruicio de vue
stra magestad. Lo qual yo escreui con tanta certinidad, que
aunque en ella se lean algunas cosas muy nueuas, y para al
gunos muy dificiles de creer, pueden sin dubda creer
las: y creer por muy cierto, que antes soy en todo
mas corto que largo: y bastara para esto auer
lo yo offrescido a vuestra magestad por
tal. Ala qual suplico la resciba en nõ
bre de seruicio: pues este solo es el
que vn hombre que saliodes
nudo pudo sacar
consigo.

Capitulo primero: en que cuenta
quãdo partio el armada, y los officiales y gẽ
te que en ella yua.

Diez y siete dias del mes d
Junio de mil y quinientos y veynte y siete
partio del puerto de sant Lucar de Barra
meda, el gouernador Pamphilo de Nar
uaez, con poder y mandado de vuestra ma
gestad para conquistar y gouernar las pro
uincias que estan desde el rio delas palmas ha
sta el cabo dela florida: las quales son en tierra firme. Y la ar
mada que lleuaua eran cinco nauios: enlos quales poco mas
o menos yrian seyscientos hombres. Los officiales que lleua
ua (porque dellos se ha de hazer mencion) eran estos que aqui se
nombran: Cabeça d vaca por thesorero y por alguazil mayor,
Alonso enrriquez, contador, Alõso de solis por fator de vuestra
magestad y por veedor, yua vn frayle de la orden de sant
Francisco por comissario que se llamaua fray Juan suarez cõ
otros quatro frayles dela misma orden: llegamos ala isla de
sancto Domingo, dõde estuuimos casi quarenta y cinco dias
proueyendo nos de algunas cosas necessarias, señaladamen
te de cauallos. Aqui nos faltaron de nuestra armada mas
de ciento y quarenta hombres, que se quisieron quedar alli
por los partidos y promessas que los dela tierra les hizie
ron. De alli partimos y llegamos a Sanctiago (que es
puerto enla isla de Cuba) donde en algunos dias que estu
uimos el gouernador se rehizo de gente, de armas, y de caua
llos. Suscedio alli que vn gentil hombre que se llamaua Vas
co porcalle vezino dela villa dela Trinidad (que es enla mis
ma ysla, offrescio de dar al gouernador ciertos bastimentos q
tenia enla Trinidad: que es cient leguas del dicho puerto de
Sanctiago. El gouernador con toda la armada partio pa

A iij

THE LIVES AND WORK of important American artists and arts communities are well documented in the Yale Collection of American Literature, especially at points of intersection between twentieth-century literature and the visual arts. The papers of painter and arts educator Robert Henri document the experiences of the Ashcan painters, artists whose work depicted American culture and life in the modern city; the Katherine Dreier papers record the history of her Société Anonyme and the artists she championed, particularly Marcel Duchamp and other European painters. Works by Picasso and Matisse; paintings by Marsden Hartley; photographs by Edward Steichen, James Van Der Zee, and Carl Van Vechten; caricatures by Miguel Covarrubias; sculpture by Augusta Savage and Isamu Noguchi; and prints by Romare Bearden suggest the range of artworks in the collection.

Activities around Alfred Stieglitz's important photography and art galleries, 291 and An American Place, and his influential publication *Camera Work,* as well as conversations and exchanges among artists and writers in the southwest are documented in the Alfred Stieglitz / Georgia O'Keeffe Archive. The archive also documents the creative lives and artistic practices of Stieglitz and O'Keeffe. While visiting Europe in 1907, Stieglitz was introduced to the Autochrome Lumière color photography process, and his papers include examples of this unusual photographic format, many taken around 1910 at Oaklawn, the Stieglitz family home in Lake George, New York. With friends and fellow photographers Edward Steichen and Frank Eugene, Stieglitz experimented with the newly patented process, photographing family and friends, including painter Dorothy Obermayer Schubart, Stieglitz's business associate Joe Obermeyer, and Stieglitz's niece Flora Stieglitz Straus.

AS ALLIES OF THE UNITED STATES, Choctaw warriors fought alongside American troops in the Creek Civil War and the First Seminole War, but afterward, as American farmers coveted the Choctaw's Mississippi homelands, they confronted enormous political challenges. In an attempt to deal with American expansion, mixed-blood Choctaw leaders created the nation's first written constitution in 1826. The new government, unable to resist Andrew Jackson's insistence that his former allies move beyond the Mississippi River, signed the Treaty of Dancing Rabbit Creek in 1830.

In 1834, the Choctaw of Indian Territory wrote a new constitution to re-establish their tribal government and assert their claims for compensation from the federal government. Disputes between supporters of traditional decentralized governance and progressives who preferred greater authority in a central administration persisted throughout the next quarter-century. In 1843 a new constitution established a bicameral legislature that satisfied neither faction. In 1857 a constitutional convention proposed replacing the three district chiefs with a single governor for the Nation. The next year, another convention proposed reinstating the district chiefs. Finally, in 1860 the Nation adopted a constitution that integrated a single national executive with the preservation of local prerogatives, including the office of district chief. The constitution of 1860 prevailed until the federal government abolished it in 1906.

The J. L. Hargett Papers, gathered from multiple sources by an Oklahoma collector and manuscript dealer of the twentieth century, provide a rare glimpse of the internal politics of a nineteenth-century Indian community. Three constitutional drafts, which reflect the evolution of ideas that contributed to the compromise constitution of 1860, are accompanied by official and personal correspondence of tribal leaders David Folsom, Thompson McKenney, and Forbis LeFlore.

Nation and who shall not ___
be an inhabitant of that ___
least Six months preceding ___
for who ____ shall be che___

Sec 4 The house ___
Composed of me____
by the gua___
ties of ___
Rep___

Sect 1 U____
___ nized, th___
shall ___
living ___
for___

See ___

Article 4

Judicial Department

Constitution of the Choctaw Nation

We the ____
Cho___

Constitution of the Choctaw Nation

We the Representatives of the people
inhabiting the Choctaw Nation contained
within the following limits, to Wit,
Beginning at a point on the Arkansas
River one Hundred paces east of Fort
Smith where the western boundary line
of the of the State of Arkansas Crosses the
said river, and running thence due
south to Red River, Thence up Red River
to the point where the meridian of
Hundred Degrees West longitude Cross
the same Thence north along said
Meridian to the main Canadian ____
Thence down said river; to its junction
with the Arkansas river, Thence down
Said river to the place of beginning except

___ ople inhabiting the
___ ithin the following
___ a point on the Arkansas
___ of Fort Smith, where
___ State of Arkansas
___ said River to the
___ Hundred degrees
___ Thence North
___ Canadian River
___ junction with
___ said river
___ the Territory
___ running on the
___ outh of ___ y to
___ into Red river ___ and
___ line below ___ such
___ running ____ and
___ channel ___
___ three prongs

51

A LIBRARY'S COLLECTION is only as good as its cataloging. Locating, gathering, conserving…none of these will matter if a book is not well cataloged or an archive not well described. Such matters may seem routine—most books have an author, a title, an imprint that can be easily identified—but some items defy easy description. With the growth and expansion of Beinecke's collections over the past few decades, our expert acquisitions assistants, catalogers, and archivists have had to devise ways of describing new and sometimes wildly inventive formats, to the point of creating new terminology that has entered into standard practice in the library field. With book objects being constructed from vinyl, textiles, concrete, and fiber, and with contemporary writer's papers accompanied by floppy disks, compact disks, and flash drives, it takes a collaborative effort to expand our systems of metadata so researchers can know what we hold.

One case in point is this structure by the artist Tamar Stone. It combines text, historical references, fabric, and metal. The description of the item, shown opposite in technical mode, was carefully crafted by one of Beinecke's rare book catalogers to provide many paths for discovery, from artist (field 100) to physical description and historical background (500s) to subjects (650s).

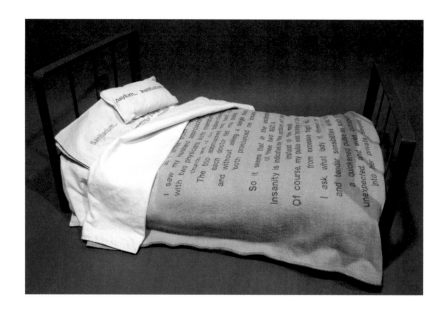

00002470crm a2200409 a 4500

0017767702

00520110303203304.0

008070105s2004 nyunnn rneng d

035:__ la (OCoLC)ocn682748865

035:__ la 7767702

040:__ la CtY-BR lc CtY-BR

043:__ la n-us---

079:__ la ocm77549135

100:1_ la Stone, Tamar R.

245:10 la Asylum-- Institution-- Sanitarium-- .

246:3_ la Sanitarium

246:3_ la Asylum-- Institution-- a place where insanity is made

246:3_ la Sanitarium-- a place for hysterical women

260:__ la [New York] : lb Tamar Stone, lc c2004.

300:__ la 1 doll bed, mattress and bedding ; lc bed 31 x 36 x 63 cm.

500:__ la A doll bed, mattress, pillow, pillowcase, flat top sheet, flat bottom sheet and blanket; all cloth items machine-embroidered with women's accounts of being declared insane, with rules of conduct from a women's jail or with statements by the artist.

500:__ la Title from front of pillow and front of pillowcase, as specified by the artist.

500:__ la Signed at end [i.e., on bottom of mattress]: Sanitarium. Tamar Stone. 2004.

500:__ la Front of pillow embroidered with "Asylum-- Institution-- "; back of pillow embroidered with " --a place where insanity is made." Front of pillowcase embroidered with "Sanitarium -- "; back of pillowcase embroidered with " --a place for hysterical women."

500:__ la Women's accounts written by Elizabeth Parsons Ware Packard, after 1851; Tirzah F. Shedd on July 7, 1865; Jane Hillyer, ca. 1920; Dee P., prisoner, Cook County Jail, 1968.

500:__ la "This institution is a branch of the [blank] County Jail. It is known as the [blank] Brand Institute for Women. Conduct rules"--Caption title on top side of mattress.

500:__ la Metal bed with chain link mattress support; top sheet, blanket, pillow cover and pillowcase of vintage cotton; bottom sheet of vintage cotton muslin; mattress of blue and white cotton ticking, hand-tied and machine- and hand-sewn.

650:_0 la Women patients lx Civil rights.

650:_0 la Women's rights lz United States.

650:_0 la Married women lx Legal status, laws, etc. lz United States.

650:_0 la Insane lx Commitment and detention lz United States.

650:_0 la Insanity lx Jurisprudence lz United States.

650:_0 la Imprisonment lz United States.

700:1_ la Packard, E. P. W. lq (Elizabeth Parsons Ware), ld 1816-1897.

7001_ la Shedd, Tirzah F.

7001_ la Hillyer, Jane.

7001_ la P., Dee.

BY THE MID-EIGHTEENTH CENTURY, Philadelphia had become a key node in the intellectual and social networks that connected American naturalists, authors, and political leaders. In 1743, encouraged by letters from Cadwallader Colden (who had practiced medicine in Philadelphia before becoming the Surveyor General of New York), Benjamin Franklin and John Bartram proposed "that one society be formed of virtuosi or ingenious men residing in the several colonies, to be called *The American Philosophical Society,* who are to maintain a constant correspondence" and that "Philadelphia, being the city nearest the centre of the continent-colonies, communicating with all of them northward and southward by post, and with all the islands by sea, and having the advantage of a good growing library, be the centre of the society."

As a publisher and as postmaster for Philadelphia, Franklin wrote, printed, and distributed the proposal, often mailing it for free. Here, his close friend, the internationally renowned naturalist John Bartram, sends Colden a copy of the printed proposal, accompanied by a brief letter describing the society's initial meetings at which "several learned & curious persons from our neighboring colonies hath already joined membership with us." He hopes that Colden will find the time to join them. Franklin assisted delivery by signing the addressed cover and marking it "Free."

Franklin and Bartram were frustrated with the pace at which the society developed. Franklin complained that members were more interested in socializing than in pursuing research, and the society was inactive for most of the 1750s. Revived in the 1760s, it was, by the end of the century, the preeminent learned society in the United States.

Esteemed Friend March y 27th 1749

I have long expected a letter from thy hand & having
received none since that sent by thy son which I answer-
ed by him: dear friend this gives me some uneasiness:
 neglect or misfortune
I should be very glad to hear oftener from thee by letter
I have here sent thee one of our proposals for form-
ing a Philosophical Society: we have already had three
meetings & several learned & curious persons from our
neighbouring colonies hath already joined membership with
us & we hope since will pleas to do us y honor to be enrol-
ed in our number. I hope this undertaking may be of
publick benefit to our american colonies if we act with
diligent application in this afair

I have little more to say at present having received no
letters from London this winter but a very learned & curious
clergy man from Bristol sent me a long catalogue of
his garden furniture which did realy pleas me

My respects to thy dear spouse & children & asure
thy selfe of y friendship & service of thy sincere
 friend John Bartram

A PROPOSAL for Promoting Useful Knowledge among the British Plantations in America.

Philadelphia May 14th 1743

THE *English* are possess'd of a long Tract of Continent, from *Nova Scotia* to *Georgia*, extending North and South thro' different Climates, having different Soils, producing different Plants, Mines and Minerals, and capable of different Improvements, Manufactures, &c.

The first Drudgery of Settling new Colonies, which confines the Attention of People to mere Necessaries, is now pretty well over ; and there are many in every Province in Circumstances that set them at Ease, and afford Leisure to cultivate the finer Arts, and improve the common Stock of Knowledge. To such of these who are Men of Speculation, many Hints must from time to time arise, many Observations occur, which if well-examined, pursued and Improved, might produce Discoveries to the Advantage of some or all of the *British* Plantations, or to the Benefit of Mankind in general.

But as, from the Extent of the Country, such Persons are widely separated, and seldom can see and converse, or be acquainted with each other, so that many useful Particulars remain uncommunicated, die with the Discoverers, and are lost to Mankind ; it is, to remedy this Inconvenience for the future, proposed,

That One Society be formed of Virtuosi or ingenious Men residing in the several Colonies, to be called *The American Philosophical Society*; who are to maintain a constant Correspondence.

That *Philadelphia* being the City nearest the Centre of the Continent-Colonies, communicating with all of them northward and southward by Post, and with all the Islands by Sea, and having the Advantage of a good growing Library, be the Centre of the Society.

That at *Philadelphia* there be always at least seven Members, viz. a Physician, a Botanist, a Mathematician, a Chemist, a Mechanician, a Geographer, and a general Natural Philosopher, besides a President, Treasurer and Secretary.

That these Members meet once a Month, or oftener, at their own Expence, to communicate to each other their Observations, Experiments, &c. to receive, read and consider such Letters, Communications, or Queries as shall be sent from distant Members ; to direct the Dispersing of Copies of such Communications as are valuable, to other distant Members, in order to procure their Sentiments thereupon, &c.

That the Subjects of the Correspondence be, All new-discovered Plants, Herbs, Trees, Roots, &c. their Virtues, Uses, &c.; Methods of Propagating them, and making such as are useful, but particular to some Plantations, more general, Improvements of vegetable Juices, as Cyders, Wines, &c. New Methods of Curing or Preventing Diseases, All new-discovered Fossils in different Countries, as Mines, Minerals, Quarries; &c. New and useful Improvements in any Branch of Mathematicks; New Discoveries in Chemistry, such as Improvements in Distillation, Brewing, Assaying of Ores; &c. New Mechanical Inventions for saving Labour ; as Mills, Carriages, &c. and for Raising and Conveying of Water, Draining of Meadows, &c.; All new

19

Offices of the Holy
Communion. Byzantine
Empire, ca. 1325. General
Collection

WE TEND TO THINK OF SCROLLS as primarily an ancient medium extinguished with the advent of the codex form at the beginning of the Christian era. MS 1155 (and other scrolls in the collections) demonstrate that the scroll form persisted well into the second millennium. While the codex was the predominant form in the Middle Ages, the scroll continued to be employed in instances where a codex would not perform as well or where the symbolism of the scroll was important. The latter is almost certainly the case here, given the great care taken with the production of the scroll and its lavish gold illumination.

MS 1155 is a Greek scroll from the early fourteenth century containing prayers to be recited by the communicant before, during, and after the Mass and read (perhaps silently) by a monk during the service. Several of these prayers are attributed to John Chrysostom (ca. 347–407) and Basil the Great (329 or 330–January 1, 379). More than thirty such scrolls survive, each with its own unique combination of prayers.

This scroll is composed of seven sheets of parchment that have been placed end to end and sewn together. There is writing on both sides, a practice not common in western European scrolls that must have made it difficult to read the text on the back because of its natural tendency to return to a roll. The colophon at the end identifies the scroll as the product of the Royal Monastery of Docheiarou on Mount Athos and implores the prayers of the reader for those who composed the manuscript. It reads: *"The present Communion [scroll] is from the Royal Monastery of Docheiarou; [it was] written and given by the hands of ancient teachers for the sake of their eternal remembrance, and the priest who reads it should commemorate them, even though their names have become forgotten."*

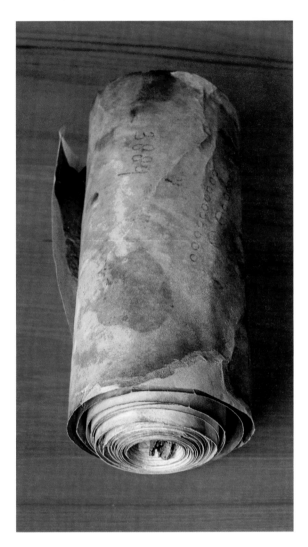

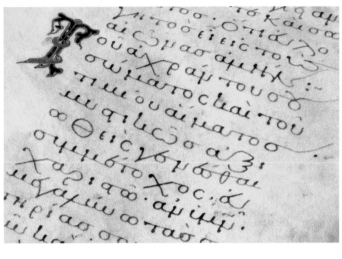

THE IDEA THAT BOOKS can be works of art is commonplace today. The medieval tradition of illuminated manuscripts, perpetuated long into the era of printed books, elaborately devised emblems, proliferating methods of book illustration, even the fine craft of letterpress printing, revived in the late nineteenth century—all have become objects of admiration and scholarship in a new approach to the book that has focused increasing attention on the relation between text and image on the printed page, an approach that owes much to the discipline of art history. But before the last century, when the "artist's book" came into its own, one rarely finds a self-conscious desire to fashion books into works of art on the part of those who actually made them.

Ever marching to the beat of his own drum, William Blake was perhaps the first to set out on this path in a modern sense, at the end of the eighteenth century. Poet, painter, and engraver by profession, Blake struggled for years to find a way to realize his vision of the book as a work of art, devising a technique he called "Illuminated Printing," which allowed him to combine text, image, and lines, creating the *mise-en-page* as a single composition directly on the copper printing plate (albeit in reverse). Blake claimed that it was the spirit of his dead brother, Robert, who finally revealed the secret to him in a dream.

Despite its name, Illuminated Printing was not a revival of the medieval tradition, but something entirely new, a kind of relief etching that essentially inverted the intaglio process he had learned as an engraver's apprentice, just as technical innovation was about to revolutionize the possibilities for illustrated printing. But Blake's artwork is not really about illustration, either. As Northrop Frye has noted, text, line, and image coexist on the page, interacting with each other in complex ways that serve to trouble rather than enhance the meanings each seems to have on its own.

The goal for Blake—as for William Morris, that other lonely pioneer of the modern art of the book, but also for many masters of the twentieth-century avant-garde—was to revolutionize consciousness, deploying art as a weapon in the struggle for social change. Known in just sixteen copies, *America: A Prophecy* did not succeed in reaching the wider audience Blake sought, but its vivid pages show the power of his radical vision at its peak.

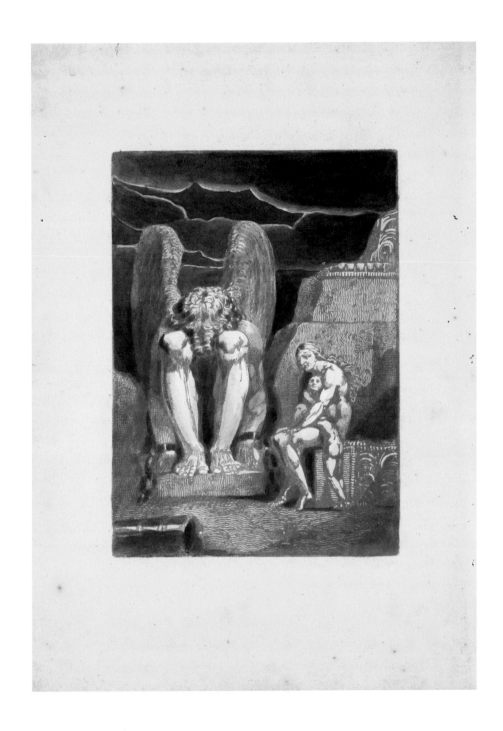

John Hancock, Workbook for penmanship, 1753.

Document commissioning Nathan Hale a captain in the nineteenth regiment of foot command by Colonel Charles Webb, signed by John Hancock. Boston, 1776.

General Collection

ONE BOOK ON ITS OWN can be of surpassing interest, rarity, and beauty, but it is in the gathering of many related examples that research collections are formed. In building the collections, the Beinecke Library's goal, over years and decades of persistent attention, is to bring individual works together in areas of new and existing strength, to build the type of critical mass necessary to support scholarly analysis and assertion. As a corollary, the director and curators often try to resist the pull of the one beautiful object that lacks context in the collections, or the acquisition of an item solely for pride of ownership. There are times, though, when single, unique items bring a bit of luster to our bronze and marble.

A case in point can be found in two items from the hand of the man who wrote history large, quite literally. Both of these arrived at Yale as gifts. The original commission for Nathan Hale was presented to the Yale Library in June 1918 by Mrs. William A. Read (most likely the widow of the owner of the well-known brokerage firm). The piece of juvenilia, John Hancock's penmanship workbook, resides in the collection put together by Betsy Beinecke Shirley, daughter of Walter Beinecke, one of the three brothers who founded the Beinecke Library.

The commission is an object of high reverence. The tale of Nathan Hale and his unfaltering dedication to the cause of a free nation, even in the face of death, has become a core lesson taught to American schoolchildren. This talented member of the Yale class of 1773 was appointed Captain of the 19th Connecticut Regiment on the first day of the fateful year 1776. His official commission was signed by John Hancock, serving as president of the Second Continental Congress, with a flourish and a paraph that has became universally recognizable on the Declaration of Independence. But years before Hancock had assumed such a public role in the formation of the United States, he practiced his signature over and over, as evidenced by his penmanship practice book from 1753, when he was 16 years old. His name, already written boldly and with beautiful clarity, appears at the bottom of the pages — on which he has written numbers, letter combinations, and aphorisms such as "Be ashamed of your pride, not proud of your shame" and "Courtesy and humility are marks of gentility."

Two collector-donors have gifted Yale with a pair of bookended touchstones to inspire students, visitors, and scholars.

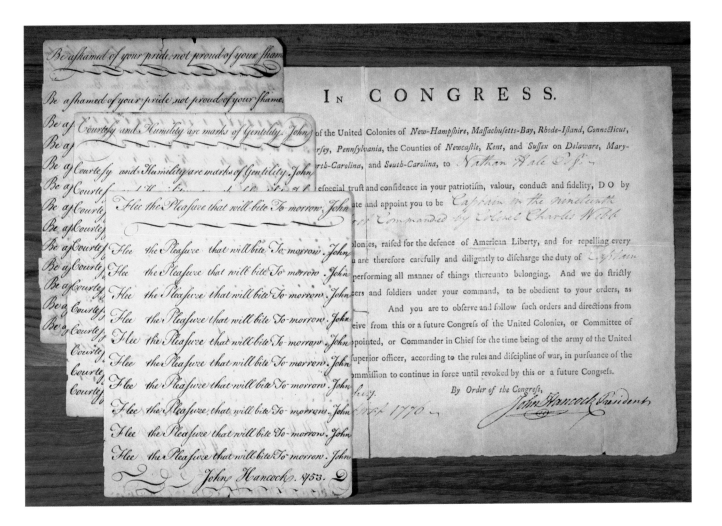

THE BEINECKE LIBRARY COLLECTIONS PERSIST, even as scholarly disciplines and methodologies change over successive generations. The Library was established at a time when many scholars were using literary analysis to create genealogy of texts. In fact, the practice of text genetics and stemmatics (the practice of creating a family tree of manuscripts and their relationships to each other) was stringently codified by critics analyzing the work of James Joyce, that most challenging and popular of modernist writers.

Joyce's manuscripts can be found in a number of libraries, including Beinecke, which holds the collection formed by John J. Slocum and Herbert Cahoon, authors of the first comprehensive bibliography of James Joyce. Their collection includes key drafts of a short section of *A Portrait of the Artist as a Young Man* and many of the stories that make up *Dubliners*.

By far the richest bed for research on Joyce, though, can be found in a group of material centering on the first section of *Finnegans Wake*, "Anna Livia Plurabelle," purchased by Beinecke Library in 1967 from Maurice Saillet, a longtime friend of Sylvia Beach, publisher of the first edition of *Ulysses*. Included in this acquisition were several sets of galley proofs and a few pieces relating to the first translation of "Anna Livia Plurabelle" into French. There are proofs from 1925 for the story's appearance in the magazine *La Navire*, but more curious are proof pages for a second translation done in 1930, for the *Nouvelle Revue Française*, where the story appeared on May 1, 1931. With Joyce attendant at most stages of the process, this translation was effected by Samuel Beckett, Alfred Péron, Eugene Jolas, Ivan Goll, Paul Léon, Philippe Soupault, and Adrienne Monnier.

With so many midwives, it may seem impossible to determine who worked on which specific passage or phrase. The object of most intense scrutiny is a single unfolded sheet of proof pages, corrected, as is generally accepted, in pen by Beckett and in pencil by Péron. But they are not here to confirm or deny who contributed which annotations. That is left to the speculation of researchers who thrill to the sight of this singular object.

Anna Livia. Dis-moi tout. Dis-moi vite. Alors, tu sais,
vieux gaillarda fit krach et fit ce que tu sais. Oui, je sais,
Lave tranquillement, et ne bats pas l'eau comme ça. Ret
manches et délie ta langue. Et ne me bouscule pas — ho !
te-penches. Ou quel quel que fût le tréfleuve qu'il aurait tr
le parc de l'Inphernix. C'est un beau salaud. Regarde-m
mise ! Regarde-moi cette saleté. Il a noirci toute mon e
pêche que ça fait déjà une samamaine que ça trempe et b
demande combien de fois je l'ai déjà lavée. Je sais par
endroits qu'il aime à saalir, le misérable. Me brûlant les
mourant de faim afin de donner au public son linge prixe.
avec ton battoir et nettoie-la. Mes poignets sont rouillés
farotter les taches de moussisure. Elle a été noyée dans la
et gangerenée par le vice. Mais, derrière tout, qu'est-ce
dimanche des Ramos ? Hélac ! Combien de cachot sans bou
a lu dans les jurneaux ce qu'il fit, nisi et prius, le roi contre
avec toute l'histoire du faux saônage et des exploits.
manafeste dans l'avonir, j'en suis sura. Le temps perdu ne s
jamais ! On récolte ce qu'on a semé. O le vieux polisson !

23

Robert Graves, *Good-bye to All That*. London, 1929. Siegfried Sassoon's copy. First edition, first issue, unexpurgated state. General Collection

HEAVILY ANNOTATED AND EMBELLISHED throughout with sardonic remarks, newspaper cuttings, and commercial illustrations, Siegfried Sassoon's copy of his friend Robert Graves's book displays the vitriolic irony and nearly obsessive, feverish intensity with which Sassoon attacked the work from the title page on. Obscuring the subtitle, "An Autobiography," are the words "Mummy's bedtime story book," while advertising slogans surround Graves's portrait.

Fixed to the verso of the title page is a letter from the publisher, Jonathan Cape, dated November 13, 1929, assuring Sassoon that a poem he had written in a private letter to Graves would be expurgated from the published text immediately: "After your call this afternoon I made arrangements for the cancel pages to be printed and to have them pasted into such copies…as have not already left our premises. I am glad to say that the number of copies which have gone out from here is only a very small percentage of the edition."

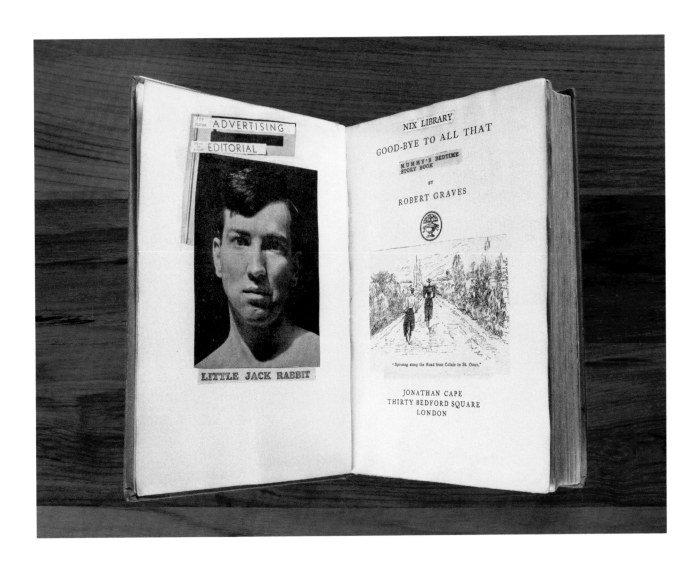

THIS LITTLE BOOK is truly an artifact. All books are, of course. But in its raw physical embodiment of a particular moment in time, of a meeting of intellectual and artistic currents, of a simple encounter between two individuals that helped spark a spirit of creative rebellion in an entire generation, *Fin de Copenhague* demands to be picked up and held in your hands. Only then, feeling the unaccustomed weight of the cardboard wrappers — the book is bound in remnants of disposable offset plates used for printing newspapers in the 1950s — running your hands over the blank raised letters reporting obsolete sensationalist news across its surface in tactile reverse, do you begin to grasp the nature of the object you are holding.

It is scavenged, the product of a willful act of appropriating popular culture that was carried out on the streets, far from the studio, the art gallery, and the poet's secluded den. It is not an object of contemplation, but an incitement to hijack, to subvert, to turn things against their makers — a process Debord and Jorn called "détournement." Inside one finds phrases, snippets, and images cut from a stack of papers the two snatched on a single visit to a newsstand in Copenhagen. Jumbled across a series of two-page layouts, the scavenged material takes on a meaning entirely different from the ones intended, the scattered phrases tied together by the "bearing structures" of an abstract painting by Jorn — lithographed and printed in offset color — on which they are superimposed — "…*et voilá,* your life transformed!"

A few months later, Debord and Jorn joined with others to found the Situationist International, one of the most significant organizations of the postwar avant-garde, and the following year they again collaborated on another masterpiece of "détournement": *Mémoires.* Bound in sandpaper (to wreck the books adjacent to it on collectors' shelves), the book shows much greater care and sophistication in its composition (entire books have been written on its exegesis). But it lacks the spontaneity of the original act of defiance, and it is also considerably less rare.

Although printed entirely in offset (itself a first for an "artist's book"), at most two hundred copies of *Fin de Copenhague* were ever run off. Coming from the collection of Alice Debord, ours is signed by both authors.

67

Alice B. Toklas and Pablo Picasso, children's chairs, in the style of Louis XV. Paris, ca. 1930. Gertrude Stein and Alice B. Toklas Papers, Yale Collection of American Literature

THE BEINECKE LIBRARY IS HOME to a variety of writers' "personal effects," objects that call to mind their daily lives, their homes, their loves, their bodies. A lock of John Keats's hair, Walt Whitman's eyeglasses, a waistcoat worn by T. S. Eliot, Goethe's pens, Langston Hughes's cigarette case — these and other objects recall their owners' very humanity. Designed by Pablo Picasso and embroidered by Alice B. Toklas, the two children's chairs in the Gertrude Stein and Alice B. Toklas Papers recall their famous Paris salon (Alice can be seen seated in one of the chairs in Man Ray's well-known portrait of the women in their apartment at 17 rue de Fleurs); perhaps more importantly, they suggest something of the dynamic creative community that met there. In *The Autobiography of Alice B. Toklas,* Stein describes how Toklas and Picasso came to collaborate on embroidered tapestries:

I did not think it possible to ask him to draw me something to work but when I told Gertrude Stein, she said alright, I'll manage. And so one day when he was at the house she said, Pablo, Alice wants to make a tapestry of that little picture and I said I would trace it for her. He looked at her with kindly contempt, if it is done by anybody, he said, it will be done by me. Well, said Gertrude Stein, producing a piece of tapestry canvas, go to it, and he did. And I have been making tapestry of his drawings ever since and they are very successful and go marvelously with old chairs. I have done two small Louis fifteenth chairs in this way. He is kind enough now to make me drawings on my canvas and to colour them for me."

The chairs reveal something of Picasso's relationship with Stein, one of the pivotal creative dialogues of the era, his relationship with Toklas, and his understanding of the relationship between Stein and Toklas, the writer's muse, wife, and chief supporter in life and art. Representing a crucial triangulation of relationships, the chairs mark an essential moment in the development of twentieth-century art and literature.

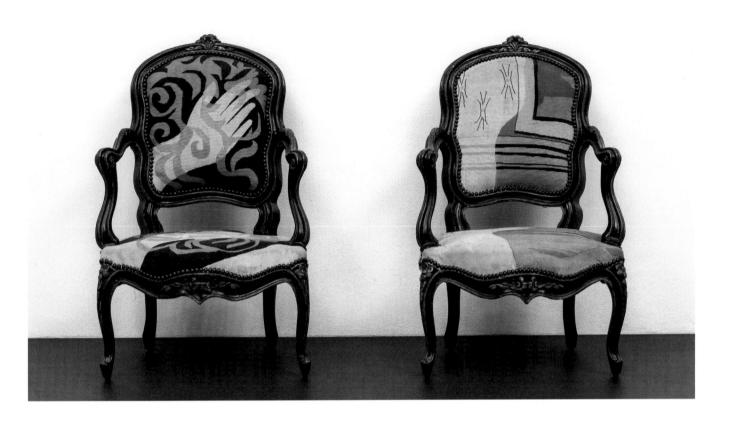

THE COMPLEX PSYCHOLOGICAL DRAMAS of Eugene O'Neill, Nobel Laureate in Literature, are counted among the most important in American literature. The Provincetown Players' Greenwich Village debut of his early work marked a major shift in American theater away from sensational melodrama and toward an often dark emotional realism. O'Neill's literary archive documents stages in the development of *Long Day's Journey into Night,* a very personal play set in his family's summer cottage on the Connecticut shoreline. In notes and drafts O'Neill refers to it as the "NL Play," his New London play. In his famously small handwriting O'Neill made lists of possible character names (including a list of surnames headed "Irish") and shifting family alliances ("Father, two sons versus Mother; Mother, two sons, versus Father); he suggests that the family's verbal "battles" should be emphasized by the cast members' movements on stage. In addition to a rough sketch of the set, O'Neill includes elaborate stage directions, describing the scene in great detail, including the titles of books on the shelves.

In 2011, the Beinecke Library acquired a typescript of O'Neill's unpublished 1919 work, "Exorcism: A Play in One Act." The autobiographical play—based on O'Neill's suicide attempt from an overdose of Veronal—premiered at the Provincetown Playhouse in New York City on March 26, 1920. Following a few performances, however, O'Neill abruptly canceled the production, retracting and destroying all copies of the script. The discovery of this famous "lost" play, possibly the only surviving copy, fills an important gap in O'Neill studies.

Scene: Living room of James Tyrone
in August,1912.
At rear are two double doorways with
at right ~~one has a glimpse of~~ a fro
arranged,set appearance of a room r
~~doorway~~ opens on a dark,windowless
as a passage from living-room to di
between the doorways is a small bo
peare ~~hanging~~ above it,containing
philosophical and sociological wor
Engels,Kropotkin,Max Sterner,plays
Swinburne,Rossetti,Wilde, Ernest D
In the right wall,rear,is a screen
extends halfway around the house.
three windows look~~ing~~ over the fro
~~which~~ runs along the waterfront.
ary oak desk are against the wall

In the left wall,~~an identical~~ similar ser
grounds in back of the house.
cushions,its head toward rear.
bookcase with ~~imposingly bound~~ s
~~two sets~~ of Shakespeare,The Worl
volumes, Hume's History of Eng
ate and ~~the~~ Empire;Smollett's
miscellaneous ~~single~~ volumes
Ireland. The astonishing th
es have the look of having

~~ished~~ hard wood floor is
nd color.~~scheme,neither~~
le with a green-shaded
sockets in the cham
ht range are four cl
t right-front of

round 8.30. Sunshine

the curtain rises,the famil
rone and her husband enter
om the dining room.

ry is fifty-four,about medi
~~rtioned,~~graceful figure.a
middle-aged ~~thick~~ waist an

27

Henri Chopin, a selection
from "Les milles pensées,"
1957–2007. Henri Chopin
Papers, General Collection

NEATLY CLASSIFIED, FOLDERED, AND DESCRIBED, the "Milles pensées" of Henri Chopin now wait quietly in their uniform gray archival boxes alongside so many others. But open just one of them, and out they come tumbling in all their glorious disarray: Chopin's "thousand thoughts," scribbled, typed, cut and pasted on anything that came to hand. Used coffee filters, cigarette butts, coins, old letters, random fliers, loose pages of unpublished work become raw material for a deeply personal process of assemblage and reminiscing on a lifetime that occupied the poet, alone in his room on many a sleepless night, in his final years.

Known to his family only from the clatter of his typewriter hammering away at all hours behind closed doors, the 3000-odd pieces of this last "work in progress" were found stuffed in two old leather suitcases, without rhyme, reason, or explanation, when the poet passed in January 2008. Untangling, configuring, interpreting the contents will keep scholars busy for decades to come. But the task is well worth the effort. For in their rambling disorder one can trace a path through a history of the twentieth century that remains to be written—a path taken in experimental poetry and avant-garde aesthetics, certainly—which for Chopin began with deportation, forced labor, and imprisonment in concentration camps, with a "death march" across Nazi-occupied Central Europe.

It was here that the future poet first grew attuned to the *sounds* of language, enticed by a cacophony of voices speaking in unknown tongues all around him along the way. The discovery would drive him (and others of his generation) to a new understanding of the nature of poetics that left a profound impact on the cultural landscapes we still inhabit today.

Scattered among reflections on current affairs, politics, religion, and impulsive remarks about friends, foes, and feuds in the avant-garde circles across Europe (and well beyond) he knew so well, Chopin's wartime memories weave in and out of the riotous chaos, a colorful and bittersweet mélange, part artwork, part biography, part poetry, part wastepaper—a work in progress now more than ever—the "Milles pensées."

READERS CAN BE FOUND living in the margins, re-writing their own (and others') books and making them their own. Hester Thrale Piozzi, friend and biographer of Samuel Johnson, filled the margins of her copy of *The Spectator* (one of the most important and liveliest of eighteenth-century English periodicals) with her acute observations on the customs of her contemporaries and social circle. "And now all the Ariettas and Cloes are taking Bark for an Appetite," she writes, with her characteristic combination of understanding and critique, "[tha]t: they may eat and grow fat; because the Prince of Wales likes Corpulent Beauties best, they say."

Piozzi's margin was a public space. Here she recorded her social thoughts, in books intended to be lent, intended to be read by friends. Here, like Johnson, she minced no words, and can be found commenting with witty, observant, often acidic eye on the fascinations of her times, her friends, and the changing landscape of her social circle. The margin can be seen as a space both private and public, situated within a reader's solitary engagement with a book and within that reader's own public — and the public of her later readers.

Purchased at auction in 2009, this copy of *The Spectator* joins other books annotated by Piozzi, including her twenty-one volume edition of the works of Alexander Pope. Here, in the Beinecke collections, Piozzi joins other friends of Johnson, in holdings ranging from the manuscript archive of James Boswell, Johnson's biographer, to the annotated proof copy of Johnson's *Dictionary of the English Language,* to the books which Johnson used as sources for his dictionary, and works owned, read, and copied by those in his always articulate, often critical circle of friends. Just as Piozzi's margins resonate with her acute commentary on those around her, so the collections bring her friend, Johnson, and their circle of comrades, colleagues, and critics together in the Library.

1926: NOVELIST BRYHER and her husband, Kenneth MacPherson, establish the first journal dedicated to film as an art form, *Close Up,* along with a film production company, The Pool Group.

1927–33: The Pool Group produces three short works: *Wingbeat, Foothills,* and *Monkey's Moon* (all of which are presumed lost after their initial screenings) along with a feature film, *Borderline,* starring Paul Robeson as the focus of a love triangle.

1931–40: The Pool Group, including the imagist poet H.D. and her daughter, Perdita, live at Kenwin, Bryher's estate in Territet, Switzerland, with a menagerie of cats, dogs, and monkeys.

1975: The H.D. Papers and the Bryher Papers are brought to Beinecke Library through relationships between the writers and Yale professor Norman Holmes Pearson.

2008: A Beinecke curator meets in Paris with a book dealer to discuss a trove of books and manuscripts related to Norman Douglas, the author of *South Wind.* The night is gentle and Paris is a city to be experienced on foot, so the pair proceed with a bit of *flânerie* that, approaching midnight, evolves into a *dérive.* A late comment issues from the book dealer: "I still don't know what to do with one thing that came with the papers—it looks like a film canister and is labeled *Monkey's Moon.*"

A glimmer, a recognition, a "please hold that thought," and the next day a phone call to New Haven to confirm: Yes, indeed, this is one of the lost short Pool films.

2009: *Monkey's Moon,* restored and digitized, is available for viewing. The world can once again see these six-and-a-half minutes of impressionistic scenes of Bryher's pet douroucouli monkeys escaping their fancy cages and gamboling around the gardens of her château in Switzerland.

2010: Beinecke Library codifies its approach to film history as focusing on the paper trail, printed materials such as scripts, stills, posters. However, restoring a gem such as *Monkey's Moon* was more of an act of cultural heritage preservation. (Besides, it is generally thought healthy to walk in the night air and freely associate.)

BEGINNING IN 1492 Europeans and Native Americans alike sought to understand each other's languages. Although this was an inherently collaborative project, the role of Indian intellectuals in creating vocabularies and orthographies for their languages is frequently overlooked. We refer to Eliot's Indian Bible, forgetting to acknowledge the role of John Sassamon, the Massachusett Indian who worked alongside Eliot for many years. It is also conventional to assume that Indian language texts were created exclusively to assist missionaries in converting Native Americans to Christianity, that such texts were ethnocentric and imperial in their purpose and effect.

First published in Montreal in 1781, the Mohawk primer challenges our assumptions. Although it was edited by a European, the German immigrant Daniel Claus, it derived from Claus's intimate friendship with Mohawk leader Joseph Brant, with whom he collaborated on several translation projects. Its function was to provide Mohawk families with a tool to learn how to read and write their own language for their own purposes. As the frontispiece for the second edition of the primer suggests, it was intended for use in schools led by Mohawk teachers. The survival in the Public Archives of Canada of manuscript letters, written by Mohawks to each other in their own language in the eighteenth and early nineteenth centuries, suggests the success of the primer, or at least of the community's intention of fostering literacy on its own terms.

That the Mohawk pursued this goal while living in what were essentially refugee camps after they had been driven from their homes by the violence of the American Revolution reflects their determination to maintain their language and their cultural autonomy.

Tomas Rathey Sculp. 1746

A

PRIMER,

FOR THE USE OF THE

MOHAWK CHILDREN,

To acquire the Spelling and Reading of their own, as well as to get acquainted with the English, Tongue; which for that Purpose is put on the opposite Page.

WAERIGHWAGHSAWE IKSAONGOENWA

Tsiwaondad-derighhonny Kaghyadoghsera; Nayondeweyestaghk ayeweanaghnòdon ayeghyàdow Kaniyenkehàga Kaweanondaghkouh; Dyorheaf-hàga oni tsinihadiweanotea.

(OO)
* O *

LONDON,
PRINTED BY C. BUCKTON, GREAT PULTNEY-STREET.
1786.

POISED BETWEEN EL LISSITZKY'S EXPLORATION of Jewish tradition and his plunge into the radical abstraction of the Russian avant-garde, this exquisite set of ten color lithographs illustrating the Passover seder is a rare surviving landmark of a crucial moment in the history of modernist graphic design.

Although issued in an edition of 90, few copies survived the suppression of the Yiddish "Culture League" (of which Lissitzky was one of the founders) in the early 1920s and the subsequent crushing of the avant-garde under Stalin. Printed on poor quality paper in the midst of the Russian Civil War and subject to indelicate treatment at the hands of children, the dust jacket is even rarer, surviving in just three known copies.

Yet it is here, in the *Had gadya* of 1919, that Lissitzky's move to abstraction and the influence of Malevich is most evident. "In Moscow in 1918 there flashed before my eyes the short circuit which split the world in two," Lissitzky wrote of the period. "This single blow pushed the time we call the present like a wedge between yesterday and tomorrow. My efforts are now directed to driving the wedge deeper. One must belong on this side or that—there is no mid-way." The last work signed with his given Hebrew name, Elizer, Lissitzky's *Had gadya* records the brief moment when the artist still stood on both sides.

Thomas Thistlewood Papers.
East Indies, Britain, and
Jamaica, 1748–86. James
Marshall and Marie-Louise
Osborn Collection

"TUESDAY 15TH: light winds fair w[eathe]r. The Negroes employ'd as before." So writes the British planter Thomas Thistlewood, in an entry for January 15, 1751, in the second of the almost ninety volumes of diaries, reading notes, and weather journals documenting his daily life managing a plantation in Jamaica from 1751 through his death in 1786. The journals, flimsy quires bound in coarse paper wrappers, once bright blue, now brown, record in his crabbed hand his daily life, observations on weather and natural history, and reading notes over almost forty years.

The Beinecke Library acquired the Thistlewood Papers in 2011 from the Lincolnshire Archive in England, where the collection had been held on deposit since 1951. The papers join Yale's holdings of English literary and historical manuscripts, as part of the Beinecke's James Marshall and Marie-Louise Osborn Collection. Thistlewood, studied already by scholars such as Douglas Hall and Trevor Burnard, becomes newly visible in the context of this collection as an early modern English reader, a participant in an Enlightenment project in which calculations of the weather were, to him, as self-evident a means of organizing his thoughts and days as the sexual relations he conducted with slave women on his plantation, or the correspondence and blood-letting and plantation management by which he framed his monthly calendar.

...ill'd off y^l Worm Tubbs, and fill'd what Cisterns...

...were empty, with... Water — Cleand...

...house, and had y^e Casks got under Cover off th...

...y^e ... frames, Swingle Trees, yoaks, Bow...

... Snips, &c brought and Cut off —

...rod y^e Negroes at a Barrell one halff off...

...Cane left Standing on about 4 Acres, He...

...burnt in y^l ... Tree Cane ... Bar Bar...

...A More in y^e Piminto Tree Cane ...

...Cutting our Cane this year in 42 days, With...

...23 $\frac{5}{42}$ hand, each day one with another —

33

The Dial, vol. 73, no. 5 (November 1922). Yale Collection of American Literature

THE YALE COLLECTION OF AMERICAN LITERATURE is home to an outstanding collection of printed and manuscript materials relating to American little magazines of the modernist era. Collaborations in this period among writers, artists, and editors resulted in the publication of numerous non-commercial, limited-circulation journals promoting new aesthetic and political ideas. These publications contributed to evolving social and cultural discussions, helping to shape the revolutionary arts movements of the period.

The collection's holdings in this area reveal trends in publishing, editorial debates, and aesthetic battles among the literary greats of the period, among them writer-editors Ezra Pound, Margaret Anderson and Jane Heap, W. E. B. Du Bois, Lincoln Kirstein, T. S. Eliot, Jessie Redmon Fauset, Marianne Moore, and Wallace Thurman. Complete runs of most important publications, including distinguished copies from writers' own libraries and unique copies annotated by poets and editors, are complemented and enriched by the extensive archival collections relating to little magazines such as *The Dial, The Little Review, Hound & Horn, Furioso, Tiger's Eye,* and *Twice A Year.* Documenting traditions and trends in literary journals and other publishing alternatives through the twentieth century, the collection continues to acquire twenty-first century underground, fugitive, and ephemeral publications.

Along with the first publication of T. S. Eliot's "The Waste Land," the present copy of the ground-breaking magazine *The Dial* includes work by Ezra Pound and Mina Loy, whose literary archives are housed in the Yale Collection of American Literature. A typescript of Eliot's poem can be found in *The Dial*/Scofield Thayer Papers (YCAL MSS 34), along with correspondence documenting the complex negotiation between the poet and *The Dial* editors over the poem's publication. Issues of the magazine from the personal library of founding curator Donald Gallup complement copies once belonging to writers H.D. (Hilda Doolittle), Carl Van Vechten, William Carlos Williams, Monroe Wheeler, and many others.

THIS PIONEERING EFFORT in photojournalism, one of the first attempts to present a comprehensive history of the American Civil War, was compiled by Alexander Gardner, a Scots immigrant who began his photographic career in 1856 at Matthew Brady's New York studio. In 1858, Gardner became director of Brady's Washington, D.C., gallery. When war broke out, he used his personal relationship with Allan Pinkerton (then head of an intelligence unit that would become the Secret Service) to gain access to a variety of Union military officers. He served as photographer in the United States Topographical Engineers and with Generals McClellan, Burnside, and Hooker. In May 1863, Gardner and his brother James opened a studio in Washington, D.C.

Shortly after the war, Gardner published his two-volume *Sketch Book.* Each volume contained fifty photographs, accompanied by Gardner's interpretive text. Unlike Brady, who frequently published photographic prints without identifying the artist who made the original negative, Gardner took pains to name the ten photographers who created the book's images. The largest body of work, forty-five images, was by Timothy O'Sullivan. Gardner took sixteen of the photographs, while ten of them were by his brother James.

In his preface, Gardner reports that the one hundred photographs were selected from nearly three thousand images made during the war. Although they were drawn almost exclusively from campaigns of the Army of the Potomac, the photographs provide a broad view of the war, arranged in chronological fashion. They depict the sites and aftermath of battles at Bull Run, Antietam, and Gettysburg, as well as forts, military structures, and people associated with the war. While scholars have focused much attention on photographs of battle dead, those pictures represent a small percentage of the contents.

Although photographs had been used to illustrate books for more than a decade, Gardner's project was unprecedented in its scale. Two thousand photographic prints were contact-printed by sunlight from original glass plate negatives. Prints were hand-mounted on boards that were bound with the text. Consequently, the two-volume set sold for $150. For context, consider that a little more than a decade earlier, deluxe editions of *Uncle Tom's Cabin* with one hundred illustrations sold for $2.50 to $5.00 depending on the quality of the binding. Beinecke's copy of Gardner's *Sketch Book* was originally owned by Matthew Perry's family.

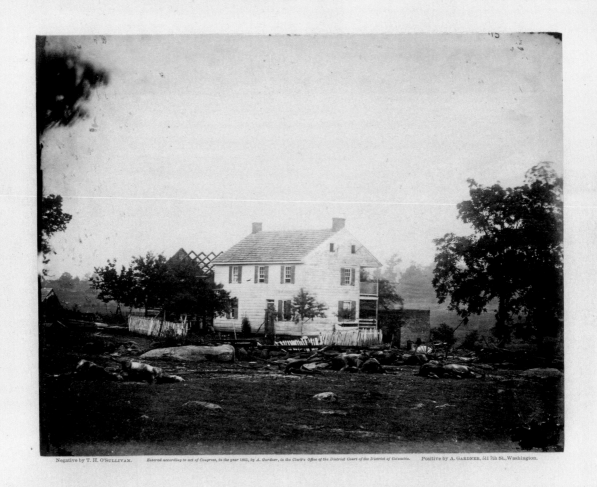

Trossell's House, Battle-Field of Gettysburg.

No. 42. July, 1863.

MOTHER COURAGE trails across the battlefield in the frontispiece to Johann Jakob Christoffel von Grimmelshausen's *Trutz Simplex* (1670), in this study of the ravages of the Thirty Years' War by one of the most influential authors of seventeenth-century German literature. Here Courage can be seen in a state of dispossession, scattering objects across a pastoral landscape re-purposed uneasily, incompletely, to the ends of war.

War was responsible for the book's presence in the Beinecke Library collections. It is part of the library of German literature composed by Curt von Faber du Faur, collector and founder of the Munich auction house Karl & Faber, who in 1939 emigrated to the United States, coming in 1944 to Yale University. The Faber du Faur collection of German baroque literature, one of the most comprehensive in North America, is now part of the Beinecke Library's broader gathering of that country's literature, extending from the sixteenth century through the twentieth.

War continues to bring readers to Grimmelshausen's commentary on the Thirty Years' War. In 1939, the year that Faber du Faur left Europe, Bertolt Brecht's reading of Grimmelshausen was taking form as *Mother Courage and Her Children.* With Brecht, we return to Mother Courage, still traveling across the landscape of a still-current war, to ask the same questions. "Let the final inscription run," Brecht writes,

(That broken slab without readers):
The planet is going to burst
Those it bred will destroy it.
As a way of living together
We merely thought up capitalism.
Thinking of physics, we thought up rather more:
A way of dying together.

Alexis de Tocqueville,
Working manuscript of
Democracy in America,
ca. 1832–40.
Yale Tocqueville
Manuscripts, General
Collection

"RUBBISH." That was the disheartening label that greeted Yale librarians who unpacked the eagerly awaited shipment in which this precious manuscript arrived from France in May 1954.

Scribbled on butcher paper wrapped around some of the unsorted bundles, the word must indeed have seemed an apt description for what at first glance looked like ream upon ream of random scrap paper. It was certainly not what they were hoping to find: the fair copy of Alexis de Tocqueville's *De la démocratie en Amérique* that Professor George Wilson Pierson had seen at the family estate over two decades before. Pierson himself had been following in the footsteps of another Yale professor, Paul Lambert White, who went to France immediately after the First World War, combing through private collections and cultivating relationships with the descendants of both Tocqueville and Gustave de Beaumont, his companion on the American journey that had inspired the book in 1830–31, all in a quest for traces of the original manuscript that seemed to be ending in a heap of "rubbish."

But it was in fact a new beginning. Once the shock and disappointment had abated, librarians discovered that the bundles contained something far more valuable than the fair copy they had been expecting: the original working manuscript of *Democracy in America*. Heavily corrected, worked over, cut and pasted, and showing substantial variations from the printed text, the manuscript now preserved at Beinecke Library has kept scholars busy for decades, collating, comparing, and laboring to untangle the creative process at work behind one of the most brilliant analyses of America ever written by a foreign observer.

37

41°, *L'éloge de Ilia Zdanevitch: nommé l'ange sur lui même.* Paris, 1922. General Collection

LONG ADMIRED AS A TYPOGRAPHIC *TOUR DE FORCE* in the world of graphic design, this small poster by Ilia Zdanevich (or Iliazd, as he preferred to be called) also poses something of a mystery to connoisseurs, who continue to be puzzled as to precisely how it was made. At first glance, it might appear to be just another example of the master's skill in pulling off feats of baffling typographic daredevilry few (if any) could match, even at the height of avant-garde experimentation with the art in the early 1920s.

After an "overnight" conversion to Futurism in Moscow and Petersburg the decade before, Iliazd had signed on as an apprentice in a printer's shop in his home town of Tiflis (now Tblisi, the capital of Georgia). Harnessing his newly acquired and intimate knowledge of the typesetter's trade to a zeal for "words-in-freedom" (the Futurists' mantra), Iliazd pushed the art of avant-garde typography to a completely new level. It was also in Tiflis that he founded the experimental group 41° and composed a cycle of five Futurist plays written in *zaum*, a quixotic invented language that, in his hands, became a supple medium for exploring the relation between sounds and their visual representation. Years later, the "sound poet" Henri Chopin would praise this work as preparing the way for the experiments that inspired his own generation in postwar Europe.

Had he remained in Tiflis, the impact of Iliazd's experimentation might have remained limited, but in 1920 he left for Paris, arriving by a circuitous route the following October, and his fifth and final *zaum* was published there in 1922 — the same year that the work shown here, *L'éloge de Ilia Zdanevitch: nommé l'ange sur lui même,* appeared. Juggling numerous styles and font sizes in a single layout, Iliazd overcame enormous technical challenges with a virtuoso's hand and mathematical precision, even going so far as to construct a font from random bits of furniture in the typecase when he could not find one big enough to suit his vision.

The acrobatics of that fifth *zaum, Ledentu le Phare* (1923), would establish his reputation in Paris. But even for a work by Iliazd, the undisputed master of modernist typography, the poster shown here has remained an inexplicable feat. How had he achieved the clean breaks that ripple right through the middle of its manifold fonts? Had he cut the type in two? Modern experts argue that this is impossible. Left to scrutinize the work itself, how should we solve Iliazd's last riddle?

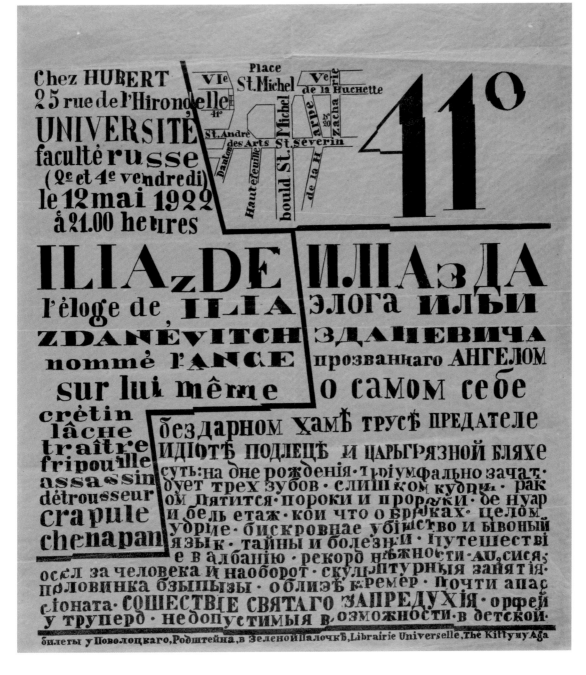

THIS BROADSIDE POEM, whose title translates roughly as "Provisional punishment, presented as a deterrent to all godless and damnable sinners," includes six sequential images showing the fate of a pair of homosexuals, from being seen in public in the first panel to death by hanging in the last. Each of the panels is inhabited by an allegorical figure symbolizing, in order of appearance: Sin, Sorrow, Fear, Suffering, Death, and the Last Judgment. The broadside is bound in a volume that includes three other works on homosexuality from the same period: another broadside on the persecution of sodomy in Holland; a lengthy compilation of legal documents from several towns in Holland on the persecution of homosexuals, complete with names of the punished or executed persons; and a commentary on Biblical teachings about sodomy.

This recent acquisition is one of the earliest items addressing overt attitudes to and treatment of sexual and affectional difference in the early modern world. From the outset, the Beinecke Library collections have documented gay and lesbian life, both in writers' archives (the papers of Gertrude Stein and Alice Toklas; Glenway Wescott; Monroe Wheeler) and in book collections (important early works on the nature of sin, for example, often focusing on the sins of the flesh). For the past twenty-five years, this focus has been deliberate and evolving. Added to the terms gay and lesbian in the 1990s were bisexuality, transgender, and more comprehensively, queer. With expanded programs of study, the umbrella widened to the appropriately expansive catch-all Human Sexuality. So the rumors about the Yale library are true — we collect material about sex — and all of its attendant anxieties, challenges, joys, and mundanities.

Recent manuscript and archival additions have included the work of gay male writers such as Edmund White and his fellow Violet Quill-wielders, while runs of magazines and anthologies of writing have helped to build the printed collections for gay and lesbian authors. In 2010, a collection of over 15,000 printed items and photographs documenting the shifting definitions of gender, gathered by Laura Bailey, came to Beinecke Library.

This contemporary material often has a decidedly positive attitude, called pride or acceptance or perhaps simply recognition. But the measure of how far the conversation about queerness has advanced can be seen in the broadside from 1731 from Holland, printed in the midst of a wave of panic over same-sex behavior — showing bodies consumed by a pyre and hanging from nooses in a presumably tolerant country.

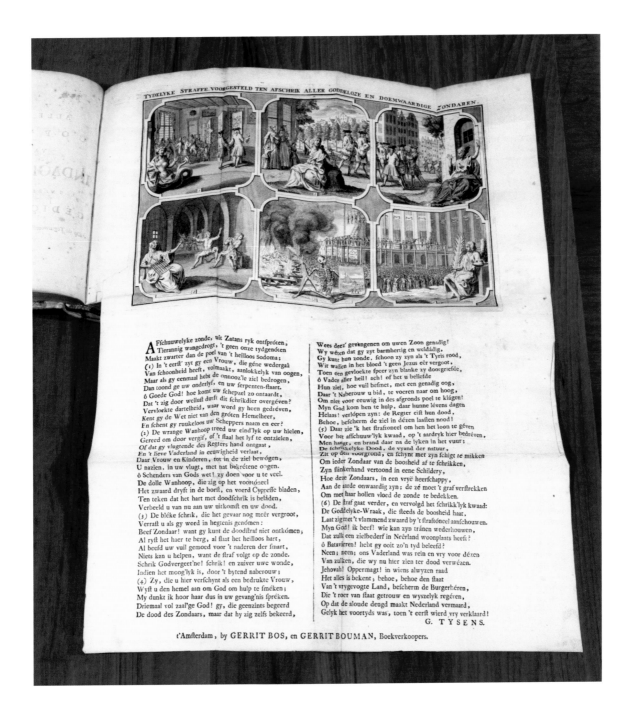

A Fschuuwelyke zonde, uit Zatans ryk ontsproten,
Tierannig wangedrogt, 't geen onze tydgenóten
Maakt zwarter dan de poel van 't heilloos Sodoma,
(1) In 't eerst' zyt gy een Vrouw, die géne wedergaâ
Van schoonheid heeft, volmaakt, aanlokkelyk van oogen,
Maar als gy eenmaal hebt de onnooz'le ziel bedrogen,
Dan toond ge uw onderlyf, en uw serpenten-ftaart.
ô Goede God! hoe komt uw schepzel zo ontaardt,
Dat 't zig door welluft dursft dit schrikdier overgéven?
Vervloekte dartelheid, waar word gy heen gedréven,
Kent gy de Wet niet van den gróten Hemelheer,
En schent gy ruukeloos uw Scheppers naam en eer?
(2) De wrange Wanhoop treed uw eind'lyk op uw hielen,
Gereed om door vergif, of 't ftaal het lyf te ontzielen,
Of dat gy vlugtende des Regters hand ontgaat,
En 't lieve Vaderland in eeuwigheid verlaat,
Daar Vrouw en Kinderen, tot in de ziel bewógen,
U nazien, in uw vlugt, met nat bekrétene oogen.
ô Schenders van Gods wet! zy doen voor u te veel.
De dolle Wanhoop, die zig op het voortóneel
Het zwaard dryft in de borft, en voerd Cyprefle bladen,
Ten teken dat het hart met doodfchrik is beláden,
Verbeeld u van nu aan uw uitkomft en uw dood.
(3) De bléke schrik, die het gevaar nog meêr vergroot,
Verraft u als gy word in hegtenis genómen:
Beef Zondaar! want gy kunt de doodftraf niet ontkómen,
Al ryft het haer te berg, al ftaat het heilloos hart,
Al beefd uw vuil gemoed voor 't naderen der fmart,
Niets kan u helpen, want de ftraf volgt op de zonde.
Schrik Godvergeet'ne! schrik! en zuiver uwe wonde,
Indien het moog'lyk is, door 't bytend naberouw;
(4) Zy, die u hier verschynt als een bedrukte Vrouw,
Wyft u den hemel aan om God om hulp te fméken;
My dunkt ik hoor haar dus in uw gevang'nis fpréken.
Driemaal vol zaal'ge God! gy, die geenzints begeerd
De dood des Zondaars, maar dat hy zig zelfs bekeerd,

Wees deez' gevangenen om uwen Zoon genadig!
Wy wéten dat gy zyt barmhertig en weldádig,
Gy kunt hun zonde, schoon zy zyn als 't Tyris rood,
Wit waffen in het bloed 't geen Jezus eêr vergoot,
Toen een gevloekte fpeer zyn blanke zy doorgriefde,
ô Vader aller heil! ach! of het u beliefde
Hun ziel, hoe vuil befmet, met een genadig oog,
Daar 't Naberouw u bid, te voeren naar om hoog,
Om niet voor eeuwig in des afgronds poel te klágen!
Myn God kom hen te hulp, daar hunne lévens dagen
Helaas! verlópen zyn: de Regter eist hun dood,
Behoe, befcherm de ziel in dézen laaften nood!
(5) Daar zie 'k het ftraftoneel om hen het loon te géven
Voor het affchuuw'lyk kwaad, op 't aardryk hier bedréven,
Men haegt, en brand daar na de lyken in het vuur;
De schrikkelyke Dood, de vyand der natuur,
Zit op den voorgrond, en schynt met zyn schigt te mikken
Om ieder Zondaar van de boosheid af te fchrikken,
Zyn flinkerhand vertoond in eene Schildery,
Hoe deze Zondaars, in een vryë heerfchappy,
Aan de aarde onwaardig zyn; de zé moet 't graf verftrekken
Om met haar hollen vloed de zonde te bedekken.
(6) De ftraf gaat verder, en vervolgd het fchrikk'lyk kwaad:
De Goddelyke-Wraak, die fteeds de boosheid haat,
Laat zigmet 't vlammend zwaard by 't ftraftóneel aanfchouwen.
Myn God! ik beef! wie kan zyn tránen wederhouwen,
Dat zulk een zielbederf in Neêrland woonplaats heeft?
ô Batavieren! hebt gy ooit zo'n tyd beleefd?
Neen; neen; ons Vaderland was rein en vry voor dézen
Van zulken, die wy nu hier zien ter dood verwézen.
Jehovah! Oppermagt! in wiens alwyzen raad
Het alles is bekent; behoe, behoe den ftaat
Van 't vrygevogte Land, befcherm de Burgerhéren,
Die 't roer van ftaat getrouw en wyszelyk regéren,
Op dat de aloude deugd maakt Nederland vermaard,
Gelyk het voortyds was, toen 't eerft wierd vry verklaard!

G. TYSENS.

t'Amfterdam, by GERRIT BOS, en GERRIT BOUMAN, Boekverkoopers.

95

As displayed facing the
Beinecke Library reading
room, photographs by
Carl Van Vechten:
Zora Neale Hurston (1940)
Richard Wright (1946)
Langston Hughes (1942)
C. L. R. James (1944)
Ella Fitzgerald (1940)
Carl Van Vechten Papers,
Yale Collection of American
Literature

TO SAY ONLY THAT THE LIFE AND WORK of photographer, writer, and cultural critic Carl Van Vechten (1880–1964) is well documented in the Beinecke collections is to understate the role he played in shaping these collections. A long-time friend of the Yale Library, Van Vechten was a tireless advocate for the Yale Collection of American Literature, encouraging friends to donate their collections and archives and collaborating with Yale librarians to acquire others.

Among his most significant and lasting contributions is as founder of the James Weldon Johnson Memorial Collection of American Negro Arts and Letters in 1941. A unique memorial, the collection honors Van Vechten's friend James Weldon Johnson (1871–1938). A celebrated poet and writer, Johnson is remembered as much for his social activism, especially as executive secretary of the N.A.A.C.P., as he is for his literary works. Grace Nail Johnson contributed her husband's papers, leading the way for gifts from many of Johnson's friends and colleagues. The James Weldon Johnson Memorial Collection celebrates the accomplishments of African American writers and artists, with a strong emphasis on those of the Harlem Renaissance.

Van Vechten's photographs document his long career as critic and promoter of the arts. He began to photograph in 1923, adopting the new technology of color photography in 1939. Over the succeeding decades, Van Vechten photographed his extensive and always expanding network of friends and acquaintances, inviting artists to sit as his subjects. Always articulate, his portraits have often become defining images of these artists, offering an always compelling, often haunting glimpse of their artistic sensibilities.

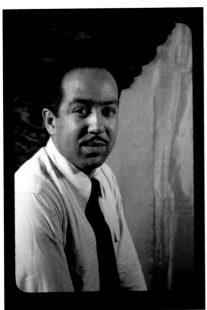
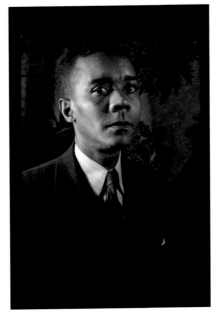
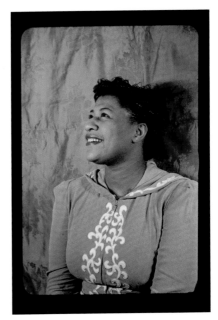

The Works of Geoffrey Chaucer, now newly imprinted. [Hammersmith]: Printed by me William Morris at the Kelmscott press, Upper Mall, Hammersmith, in the county of Middlesex. Finished on the 8th day of May, 1896. Page proof of page 63, annotated by William Morris. General Collection

This of course is the wrong measure. What is the use of sending me things which are obviously wrong? —William Morris

BALDASSARE CASTIGLIONE once defined virtuosity as the appearance of effortless mastery masking a lifetime of the diligent labors required to attain it. The Kelmscott Chaucer is in this sense truly a masterpiece of elegance. Illustrations, typeface, borders, and initials, every element on the page seems to weave together of its own accord, forming a totality that invites the reader to slip into a silent refuge of revelry and contemplation.

Yet the vitriolic comments screaming across the margins of this corrected page proof remind us that nothing came easily for William Morris, founder of the Kelmscott Press, who spent the last six years of his life laboring over every detail of the work. From the custom typeface to the 14 large borders, 18 smaller frames, and more than 200 initials he personally executed, the integration of 87 woodcut illustrations after drawings by his friend Edward Burne-Jones, the composition of each page layout, the actual work of printing on hand-made paper: each step demanded grueling effort from Morris and everyone else who was involved in the project. No wonder tempers ran short at times. "If we live to finish it," Burne-Jones wrote, "it will be like a pocket cathedral—so full of design and I think Morris the greatest master of ornament in the world."

Finish it they did, but only just. Morris died in 1896, the same year the book was published in an edition of 425 copies on paper, with an additional 13 on vellum, 48 being bound in white pigskin with silver clasps. Universally regarded as the crowning achievement of the Kelmscott Press and the culmination of a lifetime devoted to reviving traditions of handcrafted excellence, *The Works of Geoffrey Chaucer* made an enormous impact on graphic design and book production, inspiring the rise of the private press movement as well as visions of the book as a work of art in the modern sense that had slumbered since the early feats of Blake a century earlier.

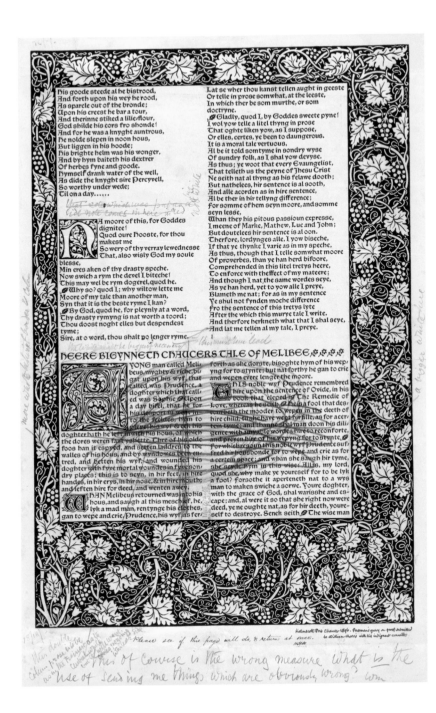

Langston Hughes, Drafts and
typescript from "Montage
of a Dream Deferred."
Langston Hughes Papers,
Yale Collection of American
Literature

POET LANGSTON HUGHES made a gift of his literary papers to the Yale University Library over many years, donating his remarkable archive to the James Weldon Johnson Memorial Collection of American Negro Arts and Letters, founded by his friend Carl Van Vechten in honor of Johnson, who was close to both men. Including photographs, letters, manuscripts, books, and other items, the archive documents the poet's life and work; in its richness and depth, the collection also reveals the vibrant culture of Harlem during the first half of the twentieth century.

Archives like the Langston Hughes Papers offer students and scholars a window on a writer's creative process; drafts of well-loved texts reveal the writer's mind at work, making choices and changes, improvements and adjustments. Drafts of Hughes's book-length work *Montage of Dream Deferred* offer an example. Though it is difficult to imagine that the work's most famous lines, those memorialized by Lorraine Hansberry's play, could have been written differently, Hughes's working drafts offer readers a chance to consider some of the alternatives the poet himself considered. In the published text, the poem below is titled "Harlem," and begins the book's final section, Lenox Avenue Mural; it is followed by "Good Morning," which appears in draft at the top of Hughes's working typescript.

What happens to a dream deferred?

Does it dry up
like a raisin in the sun?
Or fester like a sore —
And then run?
Does it stink like rotten meat?
Or crust and sugar over —
like a syrupy sweet?

Maybe it just sags
like a heavy load.

Or does it explode?

—Langston Hughes (*Montage of a Dream Deferred*, New York: Holt, 1951, p. 71)

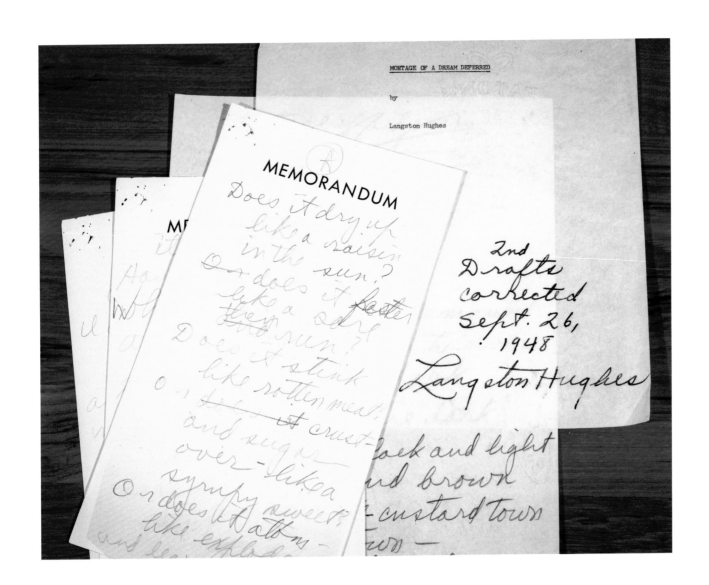

MONTAGE OF A DREAM DEFERRED

by

Langston Hughes

MEMORANDUM

Does it dry up
like a raisin
in the sun?
Or does it fester
like a sore
and then run?
Does it stink
like rotten meat,
Or does it crust
and sugar over—
like a syrupy sweet?
Or does it atom—
like explode

2nd
Drafts
corrected
Sept. 26,
1948
Langston Hughes

—lock and light
—nd brown
—custard town
—on —

IN THE SAME WAY THAT ART AND FILM have been part of Beinecke's collections, but not core areas of growth, music has always been in the Library's work and life. The Osborn Collection holds an impressive selection of music manuscripts, ranging from a sixteenth-century lute manuscript to an autograph score of Benjamin Britten's *Young Person's Guide to the Orchestra* to three core works (Symphony No. 1, *Das klagende Lied,* and *Rübezahl*) by Gustav Mahler. The papers of Ezra Pound document his efforts at composition in his opera *Cavalcanti* and his settings of the poems of Jacques Villon, while experiments such as Luigi Russolo's 1913 printed manifesto for *The Art of Noise,* the Futurist's engagement with sound, should not be overlooked.

The Beinecke Library added music history in capital letters with the gift of the Frederick R. Koch Collection in 2006 (after it had resided here for several years on deposit). In one astounding donation, Beinecke became a locus for research in nineteenth- and twentieth-century music composition. The collection, given by the Frederick R. Koch Foundation, draws researchers to New Haven to work with a wealth of music that is complemented by the collection's literary materials (which include Noel Coward's diaries, corrected proofs of Marcel Proust's *Le Cote de Guermantes,* and Henry Miller's manuscript of *Tropic of Cancer*).

In the collection are original scores for Brahm's "Alte Liebe," Cocteau's *Les Mariés de la Tour Eiffel,* manuscripts for twenty-six separate parts of Offenbach's *Les Contes d'Hoffmann,* drafts of libretti for Wagner's *Lohengrin* and *Siegfrieds Tod,* and a working draft of the libretto for Verdi's *Ernani.* The most comprehensive archives are for Ermanno Wolf-Ferrari and for William Walton, representing nearly every work he composed.

The object of highest veneration, though, may be the holograph manuscript score of Claude Debussy's *Pelléas et Mélisande.* Debussy created this break-through work of modern opera by setting his music to Maurice Maeterlinck's symbolist play, rather than adapting it as an altered libretto. As it became a classic over the decades, the score was consulted by younger composers, as shown by the manuscript, which carries evidence of its life as an archival object. The inside cover bears the bookplate of the New England Conservatory of Music, where the manuscript was held for at least six decades before being sold at auction in 1982. The circulation slip lists its own history of twentieth-century composition: Arthur Honegger, Gustav Holst, and Artur Schnabel.

43

Hoffman Gospels. Eastern
Mediterranean (Cappadocia
or Palestine), ca. 900–1000.
General Collection

THE FOUR EVANGELISTS, in four-fold emblem, can be found painted here on a background of brightest gold, in this tenth-century New Testament from the eastern Mediterranean. The manuscript—known as the Hoffman Gospels after an early twentieth-century owner, Samuel Verplanck Hoffman, who in 1912 donated the manuscript to New York's General Theological Seminary—is an example of the palimpsest of ownership, of transformation and memory, by which books encode their long histories within their material structure. This strange intermingling of text and artifact makes a book both an object and an instantiation of thought, a moment in which an author speaks to a reader across time, through the machineries of an inanimate technological device. Hoffman himself must surely have been acting in consciousness of memory: the library to which he donated the manuscript had been assembled by his father, Eugene Hoffman, book collector, wealthy clergyman, and dean of the General Theological Seminary.

Six miniatures survive in the manuscript, added in the fourteenth century to this tenth-century text; the four evangelists—Matthew, Mark, Luke, and John—are each depicted, with their emblematic devices, alongside two miniatures of the tetramorph, the divine "angel-winged creature" which combined the man, lion, ox, and eagle of the evangelical symbols. This combination of images is known in only one other surviving manuscript.

The book has been cherished over its entire eleven-hundred-year history. Some two hundred years after the addition of the miniatures, the book was re-bound, in a brocaded satin of pink, blue, and gold; in the eighteenth century, it was re-bound again, by a binder who stitched through the existing holes, retaining the original boards and stitching; a century later, it was re-bound yet again in green velvet, with the ornate silver-gilt plaque seen here. Its histories of ownership are inscribed in the text, in early annotations, in the miniatures which adorn the work, and in the succession of bindings, of owners, and sales by which the manuscript has been translated from institutional ownership into private collections and back again. In 2008, the manuscript was acquired for the Beinecke Library collections by its director, Frank Turner.

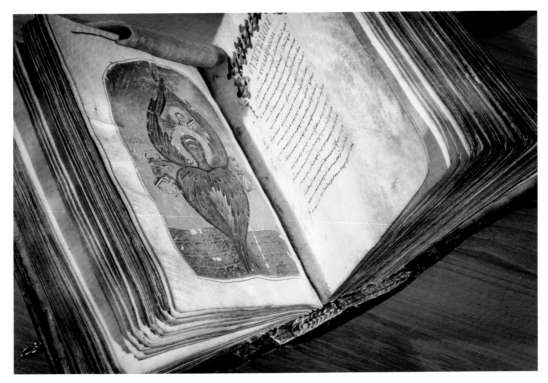

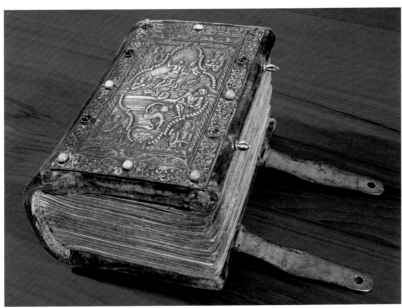

44

Bernardo de Miera y Pacheco, "Plano geografico de los descubrimientos hechos." San Felipe, Mexico, 1778.

Silvestre Vélez de Escalante, "Derrotero y diario." No place, ca. 1777.

Yale Collection of Western Americana

FOR MORE THAN A CENTURY after the Spanish colonized the Rio Grande Valley of northern New Mexico, the region remained a border province beyond which they rarely traveled. The creation of a string of missions along the California coast in the early 1770s drew the attention of Franciscan administrators in northern New Spain who wondered whether they could establish a road between Santa Fe and Monterey. In late July 1776, Fathers Francisco Atanasio Dominguez and Silvestre Velez de Escalante left Santa Fe, accompanied by a retired military engineer and cartographer, Bernardo de Miera y Pacheco, and nine other men to explore the region north and west of New Mexico.

Over the next five months the party traveled some 1700 miles through western Colorado, southeastern Utah, and northern Arizona. They reached Utah Lake, south of present day Salt Lake City, found their way through the table lands and canyons of southern Utah, and crossed the Colorado River at a place now flooded by the Glen Canyon Dam. They passed through the Hopi and Zuni villages as they made their way back to Santa Fe, where they arrived January 2, 1777.

Although the party failed to discover a path to California, Father Escalante's extensive journal and Miera y Pacheco's detailed map provided colonial administrators with abundant new information about the people and places beyond New Spain's northern provinces. Within a few decades, Alexander von Humboldt incorporated much of Miera's information into his map of New Spain, from which John C. Fremont developed his approach to exploring the Southern Rockies.

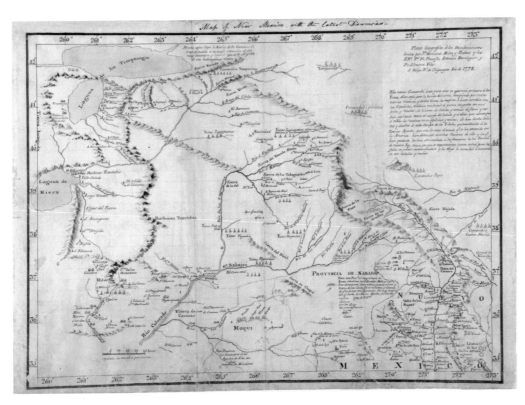

107

There are two kinds of fools. One says, "This is old, therefore it is good."
The other says, "This is new, therefore it is better." —William R. Inge

THE ACT OF BOOK COLLECTING has been described as a kind of "gentle madness" by the writer Nicholas Basbanes. Indeed, there may be a fine line between bibliophilia and bibliomania. Private collectors are driven by interests, passions, obsessions. While librarians may claim that they have a neutral interest, both camps work together to build research collections, assemblages of range and depth sufficient to support investigations in history, biography, and criticism.

Many of the greatest collections at the Beinecke Library were begun by individuals—when they were undergraduates, when they ran a press, when they had grandchildren who rekindled their interest in books. Among these collections, some have proven to be fundamental for new streams of research, while others remain curiosities, awaiting their moment of discovery. The Cary Collection of Playing Cards is one of these quieter corners of the collections.

At the heart of the Cary Collection, two groups of cards invite scrutiny: the Visconti Tarot and the Este Tarot. These two incomplete decks, both crafted in the fifteenth century, offer important linkages among art, social life, patronage, and power. The Visconti Tarot is better known, having been studied for its role in the lives of a Milanese family that dominated the cultural life of northern Italy in the fourteenth and fifteenth centuries. The designs on that deck, paint and gilt on pressed board, are attributed to the artist Bonifacio Bembo. Less well known are the Este Tarots, created for the House of Este in Ferrara. Only sixteen of these cards survive, their designs cruder and darker than the Visconti. The most evocative is the Fool, one of the trump cards, depicting an innocent beggar, exposed to the world, as fools often are, yet smiling blithely.

The building of a library—the gathering together of objects—joins introspective qualities (a passion to possess, the thrill of discovery) with a commitment to exposing these treasured pieces of evidence to others. Some might see these pursuits as a sort of madness. We see them as worthy goals, however foolhardy.

"COME ON! Set fire to the library shelves! Divert the canals to flood the museums!"

In gushing flourishes, blotches, hash marks, and scribbles, the famous lines of the Futurist Manifesto tumble haphazardly across pages of Grand Hotel stationery. A testament to Marinetti's frenzied style of composition—and to his haste in seizing an opportunity to commandeer the front page of one of the most widely read Parisian papers—the jumbled phrases, barely decipherable, seem to have little in common with the text that appeared in *Le Figaro* on February 20, 1909. Below a crude rendering of a locomotive (crossed out in blue pencil), it is just possible to make out the beginnings of one familiar rant: "The oldest of us is thirty, that means we have 10 years to accomplish our task. When we are 40, they'll throw us in the trash…" *like useless manuscripts,* so the final version continues: *we want it to happen!*

Yet for all its impulsive spontaneity, this first French draft is also a product of shrewd calculation on Marinetti's part. His attack, after all, was aimed at veneration of the Old Masters in Italy, and the manifesto itself had already been published in a small paper in Bologna some two weeks before. But the impact had been negligible. Marinetti knew that nothing would make for bigger headlines at home than provoking a scandal in the Paris press. Determined to make Futurism a household word in his own country, he bided his time until the opportunity for a splashier "premier" presented itself on the front of *Le Figaro.* "It is from Italy that we launch through the world this violently upsetting manifesto of ours," Marinetti declared in the commentary he hastily composed to accompany the French edition. "With it, we establish *Futurism,* because we want to free this land from its smelly gangrene of professors, archeologists, *ciceroni,* and antiquarians…. We mean to free her from the numberless museums that cover her like so many graveyards."

Marinetti's gambit was a success—even today the piece in *Le Figaro* is remembered as the "First Futurist manifesto"—but his assault on museums (and libraries) was less so, fortunately for us. Now preserved with countless other "useless manuscripts" in the Marinetti Papers, the draft's survival seems perhaps the ultimate irony, but one that will no doubt continue provoking "professors" and "antiquarians" for centuries to come.

WILLIAM CLARK SERVED as the principal cartographer of the expedition he led with Meriwether Lewis. Relying upon experience to estimate the distances traveled and employing a simple compass to establish directions, he drew dozens of route maps detailing the progress of the expedition. He interviewed Indians and solicited their help to sketch rough charts of regions the expedition did not visit. After he returned to St. Louis in 1806, Clark combined his personal knowledge with the accounts and maps of army officer Zebulon Pike and fur traders George Drouillard, John Colter, and Andrew Henry to develop a comprehensive map of the American West. Completed in December 1810, Clark's manuscript map opened a new era in American cartography. As the basis for the printed map which accompanied the official history of the expedition and as a chief source for most maps published before 1840, the manuscript served, for more than a quarter-century, to inform (and mis-inform) people's understanding of the American West.

Clark was the first cartographer to delineate the width, density, and complexity of the northern Rockies, to show the difficult passage between the upper Missouri River and Columbia River valleys, and to establish the great breadth of the Columbia Plateau. His map provided an extraordinarily accurate guide to the complex drainage of the Missouri Valley. Trappers, traders, scientists, and adventurers relied upon it for decades to come. As late as 1833, the German naturalist Maximilian, Prince of Wied, copied Clark's maps to guide his own voyage up the Missouri.

Clark's map was not without major error. It reflected the popular belief that the principal rivers of the West all originated near each other, and that they flowed outward from a singular high ground, the command of which would assure passage to all parts of the West. Convinced by his travels that such a spot did not exist in the northern Rockies, Clark located it in the central Rockies where such diverse rivers as the Big Horn, the Platte, the Arkansas, the Rio del Norte (Rio Grande), the Colorado, the south fork of the Lewis River, and the Multnomah River are shown to arise.

Clark retained custody of his master map throughout his tenure as Governor of Missouri Territory and later as Superintendent of Indian Affairs. The maps passed through his family until they were acquired by William Robertson Coe, who donated them to Yale in the 1940s.

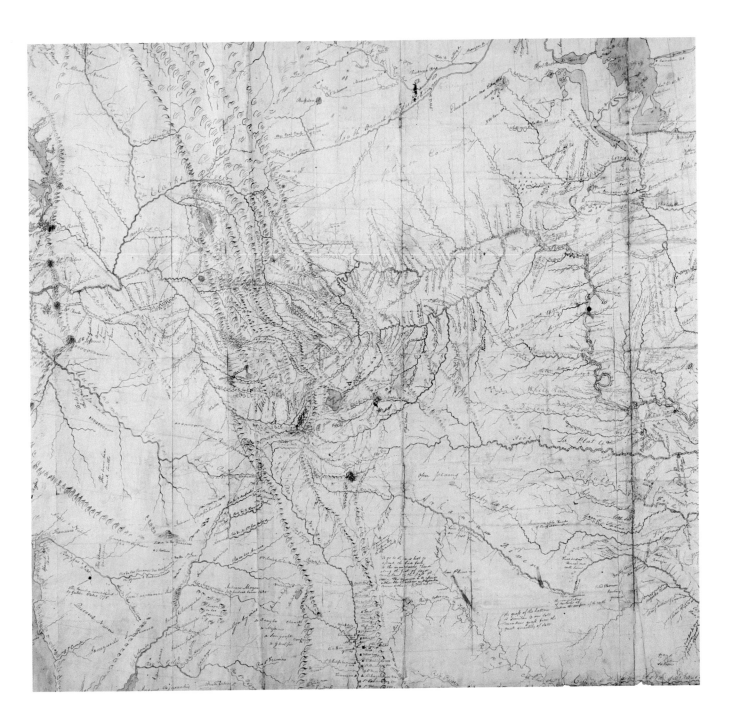

PETER PAN HAS BEEN A KEY TEXT of children's theater and literature since the premiere of the play in December 1904. This enigmatic character originated in an earlier work by J. M. Barrie, *The Little White Bird,* from 1902, and that book drew in part on experiences Barrie had watching the five Llewellyn Davies brothers at play at his cottage in Surrey. The activities of the wistful summer of 1901 were captured on photographic film by Barrie and woven into a novella in pictures, showing the older brothers playing at being pirates. The origins of *Peter Pan* can be found in this unique book, one of two copies that were bound for the author. The fate of one of the copies is unclear, likely lost shortly after it was presented to the boys' father, Arthur. This then, the sole known surviving example of what has become a mythologized relationship, resides in the Beinecke Library, courtesy of Walter Beinecke, Jr., an avid collector of J. M. Barrie books, manuscripts, and memorabilia.

This unique object can be seen as a center of gravity for collecting and preserving the legacy of J. M. Barrie. While *Peter Pan* was the sole work he created for a young audience, Barrie's immense fame and reputation were established in the 1890s and early 1900s by his sentimental novels (*The Little Minister*) and stage works (*Quality Street; The Admirable Crichton*), making him one of the best-loved writers in the English language. A hundred years later, his star has dimmed, save for the juggernaut named *Peter Pan,* a creation that overshadows most of his other work, but which allows his documentary heritage, his archives, to be preserved – owing to the perspicacity of Walter Beinecke, Jr., who sought to build as comprehensive a collection as possible.

This impulse continues to the present day. Additions to the Barrie collection at Beinecke Library now include a trove of material about the Llewellyn Davies family: their family papers, containing photo albums and hundreds of letters between Barrie and the boys. The Quiller-Couch family papers, a gift from Frederick R. Koch, hold another unique book, "The Pippa and Porthos" and an exceedingly rare Peter Pan toy theater. In this way, the Beinecke Library builds collections to strength, acquiring materials that add new dimensions to existing holdings. The result is that a writer, a literary movement, or a key event or epoch in human history may be represented by a few high-profile objects of fascination which serve as entrees to a much richer collection, one with far more complex stories waiting to be told.

THE BOY CASTAWAYS

PETER LLEWELYN DAVIES.

Published by J.M. BARRIE

Les plaisirs de l'isle enchantée, ou, Les festes, et diuertissements du roy, à Versailles: diuiséz en trois journées, et commencéz le 7me. jour de may, de l'année 1664. Paris, ca. 1673–79. General Collection

HERE WE LOOK OVER THE SHOULDER of Louis XIV of France, visible at the center of this massive folio engraving. He is held here for us in this image always on the second day of that six-day historic festival, *Les plaisirs de l'isle enchantée* — the pleasures of the enchanted isle — which he mounted at the court in Versailles in 1664 to commemorate, variously, his mother, his queen, or his mistress.

Celebrated with pageantry and fireworks, the festival also marked the first collaboration of the playwright and actor Jean-Baptiste Poquelin, known as Molière, and his friend, the composer, Jean-Baptiste Lully. The scene shown here is of the performance of one of Molière's new plays, *La Princesse d'Élide* — with *Tartuffe*, one of two new works by the playwright to debut at the festival.

The book is one in a comprehensive collection of works on Molière and seventeenth-century French theater assembled by Walter Pforzheimer, Yale graduate, book collector, and intelligence agent during the first decades of the Central Intelligence Agency. Pforzheimer's collection of French theater was rivaled only by his holdings of works on spycraft and the intelligence services. The two collections, both now held by the Beinecke Library, capture the theater of politics at its most ephemeral, and lasting, in the seventeenth century as in the mid-twentieth.

Seconde Journée
Theatre fait dans la mesme allée, sur lequel la Comédie, et le Ballet
de la Princesse d'Elide furent représentéz.

Israel Silvestre delineavit et sculp. 7.

*Hore Beate Marie ad vsum
ecclesie Sarisburiensis.*
Paris, ca. 1530. Annotated by
Sir Thomas More. General
Collection

"MORE'S PSALTER ACQUIRED BY YALE," reads the headline of *The New York Times* for Sunday, November 28, 1965, noting the gift to Yale's Beinecke Library by Edwin J. and Frederick W. Beinecke. The Library's bibliographical file for the book shows the fascination which has greeted it at Yale from its arrival through the present day, when it was chosen as the fiftieth object to join this book.

Imprisoned by Henry VIII on the charge of treason, Sir Thomas More was beheaded on July 6, 1535. While in the Tower of London, More read and wrote in this prayer book, a book of hours printed in Paris in 1530 and a psalter printed in Paris in 1522. In the margins, he has written notes in Latin toward his last work, the *Dialogue of Comfort against Tribulation,* published after his death, and a prayer, in English:

Give me thy grace, good Lord,
To set the world at nought;
To set my mind fast upon thee,
And not to hang upon the blast of men's mouths;
To be content to be solitary;
Not to long for worldly company;
Little and little utterly to cast off the world,
And rid my mind of all the business thereof.

The book was selected in a public vote by the Beinecke Library staff, members of the Yale University community, and the Library's broader audiences, as the fiftieth object to be included in this collection. The world has long since been cast off by More and his monarch, but the prayer book remains with us as a reminder of a particular moment, and of the ability of these collections to draw our attention to the understanding of the past.

Matris coz hginett threna totii trinit.
Quando suū filiū nocte captū sciut.
Ductum ad pzetozium mane cum audiut.
Frequens dans suspirium/sepe singultiuit
bstus. Te laudamus z rogamus mater iesu
christi. Rem. Ut intendas et defendas nos a
mozte tristi. Ozemus. Oratio.
Omine sancte Jesu fili dulcis virgi-
nis marie qui pzo nobis mozte in cru-
ce tolerasti/fac nobiscum misericozdiā tuā z
da nobis z cunctis compassionem tue sanctis
sime matris deuote recolentibus eius amoze
bitā in pzesenti gratiosam/z tua pietate glo
riam in futuro sempiternam. Ju qua viuis
z regnas des. Per omnia secula seculozum.
Threnosa cōpassio dulcissime dei matris:
perducat nos ad gaudia summi dei patris.
Amen. Benedicamus domino. Deo gratias.

Ad pzimam.

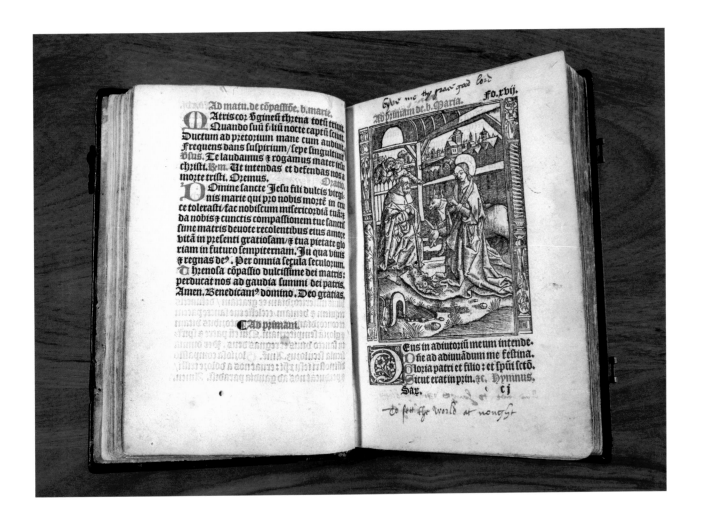

Eus in adiutoziū meum intende.
Dfie ad adiuuādum me festina.
Glozia patri et filio: et spū sctō.
Sicut erat in pzin. zc. Hymnus,
Say. cj

to sett the world at nought

Corrected proof, illustrating the typeface for the bronze door into the Beinecke
Library stack tower (opposite). Yale University Building Project Records (RU 5).
Manuscripts and Archives, Yale University Library

THE BEINECKE RARE BOOK AND MANUSCRIPT LIBRARY

MAY THIS LIBRARY, GIVEN TO YALE UNIVERSITY
BY EDWIN JOHN BEINECKE, FREDERICK WILLIAM BEINECKE AND WALTER BEINECKE, THREE YALE MEN,
STAND AS A SYMBOL OF THE LOYALTY AND DEVOTION OF THREE BROTHERS,
AND SERVE AS A SOURCE OF LEARNING AND AS AN INSPIRATION TO ALL WHO ENTER

Acknowledgments

It would be impossible to acknowledge the many contributions that have made this book possible. The book celebrates, first and foremost, the fiftieth anniversary of a gift, by Edwin J., Frederick W., and Walter Beinecke, that allowed these collections to be gathered together, in a building of extraordinary grace, to the immeasurable benefit of students and scholars.

The works in this book are shown as they are encountered in the Library's reading room and stacks each day, as three-dimensional artifacts alive with the textures, histories, and imperfections that make the collections more than the sum of texts they contain. David D. Driscoll, Bob Halloran, and Meredith Miller — Senior Photographers of the Beinecke Library's Digital Studio — brought extraordinary skill and patience to the task of revealing the character of each work, photographing not only the books but also the building. Chris Edwards supported and facilitated the project from its earliest planning sessions through the final photographs. Olivia Hillmer, Moira Fitzgerald, Stephen Jones, John Monahan, and the staff of the Library's Access Services department patiently organized the movement of the fifty books and manuscripts throughout the project, as they were required for exhibitions, classes, and in the reading room.

Each of the Library's curators nominated ten works to include in this collection. In this, the book represents one of the Library's singularities: the range and depth of the Beinecke Library collections, extending from a manuscript donated to the early college by Elihu Yale to works by living authors. Individually, each item is remarkable; together, the whole transcends its parts. The same could be said of the Library's curators, who worked together on a project that drew as much on each curator's expertise in a particular collecting area as on the curators' shared understanding of the collections as a whole. Originating in discussions with Louise Bernard, then the Yale Collection of American Literature Curator for Prose and Drama, the book finished with contributions by a new colleague, Raymond Clemens, Curator for Early Books and Manuscripts. The intellectual generosity and dedication brought by the Beinecke curators and director to the Library and its collections can be seen throughout this book.

The project drew on the contributions of many across the University, and beyond. Christa Sammons, Curator Emerita of the Yale Collection of German Literature, advised and edited throughout the book's production with her customary grace and acuity. Heather Dean, Bill Landis, Stephen Ross, and Rebecca Hatcher together made it possible to include a proof version of the inscription on the Beinecke's bronze door, an image drawn from the collections of the Yale University Library Manuscripts & Archives department. John Gambell and Rebecca Martz, in the Office of the University Printer, brought an invaluable eye to the design of this book, guiding it through all stages of its production. We are grateful as well to the Carl Van Vechten estate for permission to reproduce the five Kodachrome portraits from his archive.

No acknowledgment would be complete without mention of the Beinecke staff, researchers, faculty, and students who bring continued vitality and enthusiasm each day to these collections. Suggested by curators Timothy Young and Nancy Kuhl, this book's title — taken from the inscription on the bronze door to the central book tower, visible each day to all who enter the Library — recognizes one of the Library's most remarkable contributions, and the enduring strength of the Beinecke brothers' gift. Each day, in the reading room, the classroom, on the digital screen, the Library and its collections continue to inspire the curiosity, passion, and dedication of all those who enter.

Fifty Works

1 *Speculum humanae salvationis.* England, 1400–1410. General Collection

2 Slavko Kopač, *Tir à cible.* Paris: L'Art brut, 1949. General Collection

3 Phillis Wheatley, *Poems on Various Subjects, Religious and Moral, By Phillis Wheatley, Negro Servant to Mr. John Wheatley, of Boston, in New England.* London: Printed for A. Bell, bookseller, Aldgate; and sold by Messrs. Cox and Berry, King-street, Boston, 1773. Yale Collection of American Literature

4 Papyrus fragment P.CtYBR inv. 4510. Roman Empire, early second century, C.E. General Collection

5 Susan Howe, details from "Spleenwort" and "Tableland," from *Gardens,* ca. 1972–73. Susan Howe Papers, Yale Collection of American Literature

6 Jonathan Edwards, Manuscript notes for a sermon on Deuteronomy 32:35: "There is nothing that keeps wicked men at each moment out of hell but the meer pleasure of God" (Delivered at Enfield, Connecticut, 1741). Jonathan Edwards Papers, General Collection

Sinners in the Hands of an Angry God. A Sermon Preached at Enfield, July 8th 1741. At a Time of Great Awakenings; and Attended with Remarkable Impressions on Many of the Hearers. Boston, 1741. General Collection

7 Abonnement *Mécano.* Leiden: Administratie *De Stijl,* ca. 1922. General Collection

8 William H. Townsend, Sketches of the *Amistad* captives. New Haven, ca. 1839–40. General Collection

9 Voynich Manuscript. Central Europe? Fifteenth century? General Collection

10 The Codex Reese. Mexico City, ca. 1565. Yale Collection of Western Americana

11 Manuscript drafts and notes by Walt Whitman. Walt Whitman Collection, Yale Collection of American Literature

12 Folding merchant's calendar. Paris, ca. 1290–1300. General Collection

13 *To the settlers in Austins settlement.* San Antonio de Bexar, 1823. Yale Collection of Western Americana

14 Álvar Núñez Cabeza de Vaca, *La relacion y comentarios del gouernador Aluar nuñez cabeça de vaca.* Valladolid, 1555. The Henry C. Taylor Collection, General Collection

15 Alfred Stieglitz, Autochrome portrait of Flora Stieglitz Straus. Lake George, ca. 1915. Alfred Stieglitz / Georgia O'Keeffe Papers, Yale Collection of American Literature

16 Choctaw Nation, Three drafts for a tribal constitution. Doaksville?, Choctaw Nation, 1858–59. J.L. Hargett Collection of Choctaw Nation Papers, Yale Collection of Western Americana

17 Tamar R. Stone, *Asylum—Institution—Sanitarium.* New York: Tamar Stone, 2004. General Collection

18 Benjamin Franklin, *A Proposal for Promoting Useful Knowledge among the British Plantations in America.* Philadelphia, 1743. A copy with John Bartram's manuscript letter to Cadwallader Colden, March 4, 1744, franked by Franklin. General Collection

19 Offices of the Holy Communion. Byzantine Empire, ca. 1325. General Collection

20 William Blake, *America, A Prophecy.* Lambeth, 1793 [i.e. 1794]. General Collection

21 John Hancock, Workbook for penmanship, 1753.

Document commissioning Nathan Hale a captain in the nineteenth regiment of foot command by Colonel Charles Webb, signed by John Hancock. Boston, 1776.

General Collection

22 James Joyce, detail from "Anna Livia Plurabelle." Proofs with corrections in pen by Samuel Beckett and in pencil by Alfred Péron, Paris, ca. 1930. James Joyce Papers, General Collection

23 Robert Graves, *Good-bye to All That.* London, 1929. Siegfried Sassoon's copy. First edition, first issue, unexpurgated state. General Collection

24 *Fin de Copenhague / Asger Jorn; conseiller technique pour le détournement, G.E. Debord.* [Copenhagen]: Le Bauhaus imaginiste, 1957. General Collection

25 Alice B. Toklas and Pablo Picasso, children's chairs, in the style of Louis XV. Paris, ca. 1930. Gertrude Stein and Alice B. Toklas Papers, Yale Collection of American Literature

26 Eugene O'Neill, Notes, sketches, and corrected drafts from *Long Day's Journey into Night*, ca. 1939–40. Eugene O'Neill Papers, Yale Collection of American Literature

27 Henri Chopin, a selection from "Les milles pensées," 1957–2007. Henri Chopin Papers, General Collection

28 *The Spectator*, vol. 5 (1789). Hester Thrale Piozzi's annotated copy. General Collection

29 *Monkey's Moon*. Pool Group, 1929. General Collection

30 *A Primer for the Use of the Mohawk Children, To acquire the Spelling and Reading of their own, as well as to get acquainted with the English Tongue; which for that Purpose is put on the opposite Page*. London, 1786. General Collection

31 El Lissitzky, *Had gadya*. Kiev: Kultur-Lige, 1919. General Collection

32 Thomas Thistlewood Papers. East Indies, Britain, and Jamaica, 1748–86. James Marshall and Marie-Louise Osborn Collection

33 *The Dial*, vol. 73, no. 5 (November 1922). Yale Collection of American Literature

34 Alexander Gardner, *Gardner's Photographic Sketch Book of the War*. Washington, 1865–66. General Collection

35 Hans Jakob Christoph von Grimmelshausen, *Trutz Simplex, oder, Ausführliche und wunderseltzame Lebens-Beschreibung der Ertzbetrügerin und Landstörtzerin Courasche*. Nürnberg, ca. 1670. Faber du Faur Collection, General Collection

36 Alexis de Tocqueville, Working manuscript of *Democracy in America*, ca. 1832–40. Yale Tocqueville Manuscripts, General Collection

37 41°, *L'éloge de Ilia Zdanevitch: nommé l'ange sur lui même*. Paris, 1922. General Collection

38 Gysbert Tysens, *Tydelyke straffe voorgesteld ten afschrik aller goddeloze en doemwaardige zondaren*. Amsterdam, ca. 1731. General Collection

39 As displayed facing the Beinecke Library reading room, photographs by Carl Van Vechten: Zora Neale Hurston (1940) Richard Wright (1946) Langston Hughes (1942) C.L.R. James (1944) Ella Fitzgerald (1940) Carl Van Vechten Papers, Yale Collection of American Literature

40 *The Works of Geoffrey Chaucer, now newly imprinted.* [Hammersmith]: Printed by me William Morris at the Kelmscott press, Upper Mall, Hammersmith, in the county of Middlesex. Finished on the 8th day of May, 1896. Page proof of page 63, annotated by William Morris. General Collection

41 Langston Hughes, Drafts and typescript from "Montage of a Dream Deferred." Langston Hughes Papers, Yale Collection of American Literature

42 Claude Debussy, detail from *Pelléas et Mélisande*, 1893–1901. Short score, holograph. Frederick R. Koch Collection

43 Hoffman Gospels. Eastern Mediterranean (Cappadocia or Palestine), ca. 900–1000. General Collection

44 Bernardo de Miera y Pacheco, "Plano geografico de los descubrimientos hechos." San Felipe, Mexico, 1778.

Silvestre Vélez de Escalante, "Derrotero y diario." No place, ca. 1777.

Yale Collection of Western Americana

45 Fool, from the Este Tarot. Italy, ca. 1450. Cary Collection of Playing Cards

46 Filippo Tommaso Marinetti, "La foundation du futurism et son manifeste." Paris, 1909. Filippo Tommaso Marinetti Papers, General Collection

47 William Clark, detail from "A Map of Part of the Continent of North America… Shewing Lewis & Clark's rout over the Rocky Mountains in 1805 on their rout to the Pacific from the United States." St. Louis, 1810. Yale Collection of Western Americana

48 J.M. Barrie, *The Boy Castaways of Black Lake Island, being a record of the terrible adventures of the brothers Davies in the Summer of 1901, faithfully set forth by Peter Llewelyn Davies*. London: Published by J.M. Barrie in the Gloucester Road, 1901. General Collection

49 *Les plaisirs de l'isle enchantée, ou, Les festes, et diuertissements du roy, à Versailles: diuiséz en trois journées, et commencéz le 7me. jour de may, de l'année 1664*. Paris, ca. 1673–79. General Collection

50 *Hore Beate Marie ad vsum ecclesie Sarisburiensis*. Paris, ca. 1530. Annotated by Sir Thomas More. General Collection

Designed and set in Yale and Univers typefaces by John Gambell and
Rebecca Martz in the Office of the Yale University Printer
Edited by Christa Sammons
Printed by Editoriale Bortolazzi Stei S.R.L., Verona, Italy
Distributed by Yale University Press

Cover photograph: David D. Driscoll
Frontispiece and Introduction photographs: C. T. Alburtus. Beinecke Rare
 Book and Manuscript Library Construction Photographs, 1961–63.
 General Collection
Director's Preface photograph: Meredith Miller
Inscription photograph: Bob Halloran
Object photographs: David D. Driscoll, Bob Halloran, Meredith Miller